MIDDLEWOOD JOURNAL: *Drawing Inspiration from Nature*

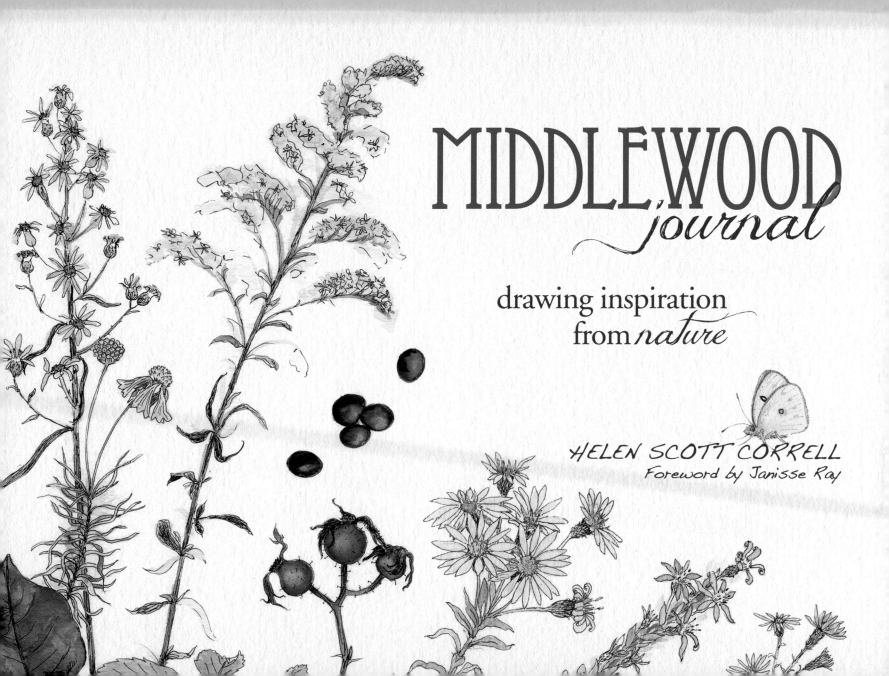

MIDDLEWOOD
journal

drawing inspiration
from *nature*

HELEN SCOTT CORRELL
Foreword by Janisse Ray

Second printing, January 2017
Printed in China

Cover and book design: Brandy Lindsey, The Graphics House
Hub City editor: Kari Jackson
Proofreaders: Nancy Rosenwald, Erin Haire

Correll, Helen Scott.
Middlewood journal: drawing inspiration from nature / by Helen Scott Correll; foreword by Janisse Ray. – 1st ed.
 p. cm.
ISBN 978-1-891885-97-6 (pbk. : alk. paper)
1. Correll, Helen Scott–Blogs. 2. Natural history–South Carolina. 3. Natural history–South Carolina–Pictorial works. I. Ray, Janisse, 1962- II. Title.
QH105.S6C67 2012
508.757–dc23

 2012015947

186 W. Main St.
Spartanburg, SC 29306
864.577.9349
www.hubcity.org

For Ben, who made this possible

DONORS

The Hub City Writers Project thanks its friends who made contributions in support of this book and other Hub City programs:

Nora Beth and John Featherston

Paula and Stan Baker

Bill and Valerie Barnet

Colonial Trust Company

Susan and Ken Couch

Elizabeth Fleming

Marsha and Jimmy Gibbs

Carlos and Barbara Gutierrez

George Dean and Susu Johnson

Julian and Dorothy Josey

Caroline and William Keith

John Lane and Betsy Teter

Sara, Paul, and Ellis Lehner

Nathaniel and Gayle Magruder

Jeannie and Patrick O'Shaughnessy

James T. Rambo

William and Sarah Scott

J.M. Smith Foundation

Sally and Warwick Spencer

Madeline and Jeff Thompson

Mary A. Walter

White's Pine Street Exxon

Alanna and Dan Wildman

Anne Marie and Dennis Wiseman

IN MEMORY OF PATRICK GRIMES, WHO LOVED HELEN

Arkwright Foundation

Nancy and Chuck Baldwin

Marianne and Tom Bartram

Charles and Christi Bebko

Shirley Blaes

Barbara and David Brewer

Bea Bruce

Myrna Bundy

Julia Burnett

Robert W. and Margaret S. Burnette

Kathy and Marvin Cann

Peter Caster

Ruth Cate

Nan and Tim Cleveland

Randall and Mary Lynn Conway

Helen and Ben Correll

Correll Insurance Group

Scott Correll

Paul and Nancy Coté

Tom Moore Craig

John and Kirsten Cribb

C. Michael Curtis and Betsy Cox

Fredrick B. Dent

Paul and Tara Desmond

Chris and Alice Dorrance

Arthur Farwell III and Elizabeth Drewry

William C. and Betty Elston

Edwin Epps

Jan Scott and Terry Ferguson

Beth Cecil and Isabel Forbes

Steve and Abby Fowler

H. Laurence and Elizabeth Fritz

Joan Gibson

Ellen Goldey

Margaret and Chip Green

Andrew Green

Roger and Marianna Habisreutinger
Lee and Kitty Hagglund
Bob and Barbara Hammett
Robert and Carolyn Harbison, III
Peyton and Michele Harvey
Michael and Sally Hastings
Mark Hayes
Jonathan Haupt
Mike and Nancy Henderson
Peggy and David Henderson
J. Thomas and Max B. Hollis
Marion Peter Holt
Doug and Marilyn Hubbell
Mr. and Mrs. Kenneth R. Huckaby
Jim and Patsy Hudgens
Joe and Elsa Hudson
David and Harriet Ike
Virginia Jenkins
Chris and Manya Jennings
Stewart and Ann Johnson
Wallace Eppes Johnson
Betsy and Charles Jones
Frannie Jordan
Jay and Pam Kaplan
Mr. and Mrs. Daniel Kahrs
Ann J. Kelly
Cecil and Mary Jane Lanford
Eric and Brandy Lindsey
Brownlee and Julie Lowry
Kelly Lowry and Rebecca Ramos
Kim McGee and Venable Vermont
Zerno Martin
Ed and Gail Medlin

Larry E. Milan
Don and Mary Miles
Boyce and Carol Miller
Karen and Bob Mitchell
Robin Mizell
Carlin and Sander Morrison
Rick Mulkey and Susan Tekulve
T. Craig Murphy
Susan and John Murphy
Kam and Emily Neely
George and Margaret Nixon
Walter and Susan Novak
Mr. and Mrs. W. Keith Parris
Fred and Patrice Parrish
Steve and Penni Patton
Carolyn Pennell
John and Lynne Poole
L. Perrin and Kay Powell
Philip N. and Frances M. Racine
Eileen Rampey
Allison and John Ratterree
Naomi Richardson
Rose Mary Ritchie
Martial and Amy Robichaud
Gail Rodgers
Steve and Elena Rush
Kaye Savage
Prudence Scott
Lee and James Snell, Jr., Esq.
Eugene and Rita Spiess
Tammy and David Stokes
Phillip Stone
Brenda and Ed Story

Frank Thies III
Ray E. Thompson, Sr.
Bob and Cheryl Tillotson
John and Charlotte Verreault, III
Melissa Walker and Chuck Reback
William R. Walter
Mary Ellen Wegrzyn
David and Kathy Weir
Karen and John B. White, Jr.
Rochelle Williams
Mary G. Willis
Stephen Willis
Cynthia and Stephen Wood
Bob and Carolyn Wynn
Steve and Charlotte Zides

*Tiny sparkleberry
turning pink*

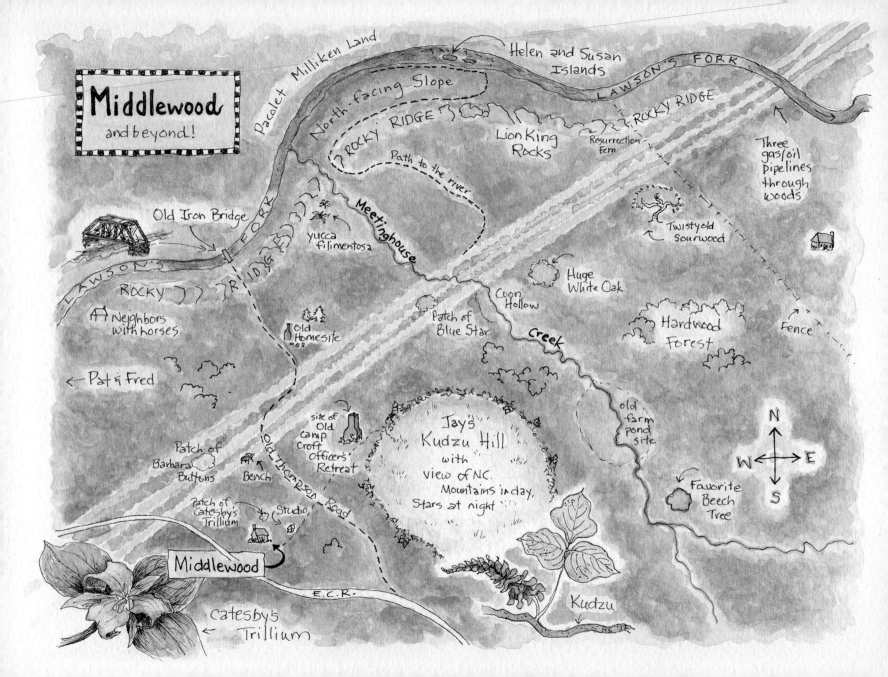

INTRODUCTION *helen scott correll*

I believe the idea of keeping a nature journal had already germinated back when my husband and I built our house, Middlewood, in the woods. Maybe even in college, when my great interests battled for attention: Biology, Botany, or Fine Art? Before that, one might think the six formative years in Jacksonville, Florida, attending a small girls' school named for early naturalist William Bartram, his botanical and zoological drawings decorating the walls, could have planted the seed.

But none of that would have mattered if I hadn't grown up with parents who did not like us watching television. Oh, my sisters and I would try! We'd rise early on Saturdays and tiptoe into the den to sneak cartoons, always underestimating our parents' acute sense of hearing. One minute later: *thump, thump, thump* … footsteps in the hall, and then *click* … off went *The Jetsons* or *The Flintstones*. "Go outside," they said.

I have vivid memories of my backyard investigations and, later, solitary rambles through the North Florida Pine/Saw Palmetto forests of Mandarin, beside the St. Johns River, and childhood discoveries there: a green snake, plucked off a branch, twining around my fingers; a brilliant orange tiger lily glowing beneath pines; a patch of dainty rose pogonias, a native orchid, growing in a ditch. Back then I drew plants and animals from *National Geographic* magazine and made "books" from folded paper in which I worked. So perhaps the surprise is not that I decided one day to hike into my very own woods to draw, but that I didn't do it sooner.

In 2008 I started Middlewood Journal blog to share my journal pages. The essay descriptions were to tell my readers (and to remind myself) of the *where, when,* and *how* of each day's trek. I hope there is no doubt about *who* and *why.*

Acorns sprouting on a sandy bank

FOREWORD
Janisse Ray

Sometimes the stars get crossed up, and backwards things happen. No other explanation accounts for a day twelve years ago along Lawson's Fork near Spartanburg, South Carolina, when I was teaching a subject I was unqualified to teach: nature journaling. And Helen Correll had signed up for the class.

The class started at 9 a.m. on a clear, sunny spring morning. I had no idea what I was up against. First I had everyone sit quietly and listen to the woods. I heard the low rumbling of traffic like a waterfall, I heard birds calling. The April sun shining through millions of new leaves turned the air green, so that breathing was like drinking chlorophyll.

I wrote that line down in my nature journal, my wannabe field journal, the one whose cover was taped with wild turkey feathers and postage stamps of birds, including the one-cent kestrel.

After some gesture drawing and blind contour drawing, I had everybody wander around the woods observing signs of spring, then documenting the season with words and sketches—sapling maple growing from moss, the tulips of poplar, honeysuckle. I happened to find myself on a log near Helen Correll.

When Helen opened her notebook to draw, salamanders crawled out. Butterflies flew from unlined pages. Southern ragwort and daisy fleabane rose up from hillsides of flowers.

I couldn't believe what I was seeing. "Show me more," I said, and Helen turned more pages. Berries dropped out. Pawpaw bloomed. Strange beetles emerged from beneath the pencil-marks of a remarkable hand.

"I'm the wrong person teaching this class," I said. Helen smiled at the compliment and started drawing. "Seriously," I said.

In her well-liked poem "The Summer Day," naturalist and poet Mary Oliver writes, "I do know how to pay attention, how to fall down into the grass, how to kneel down in the grass …."

Helen could be the narrator of that poem. She has given her adopted home-region, the Piedmont of South Carolina, the unsayable gift of paying attention to it, of making herself a devotee of it, and of studying it— hour after hour and day after day of watching, waiting, recording, while breezes bend the grasses and rufous-sided towhees rustle dead leaves on the forest floor. Helen has, thereby, become intimate with her place. It is not so much that she has developed a sense of place as much as she has become one with it.

In 2011 I returned to Spartanburg to join a group of local scholars focusing a week's attention on the village of Glendale, trying to learn its stories and its nature. Again I found myself in the fine and gentle company of Helen. This time I was able to pore over her naturalist notebooks, journal after journal that exhibited a stellar knowledge of the biota of her environs and that reminded me of Henry David Thoreau when he said, "Here I am at home. In the bare and bleached crust of the earth I recognize my friend." Her journals engendered in me a profound peace that was itself a form of meditation.

I will never be the kind of naturalist that I would like to be. Helen, however, reminds me to keep walking, keep studying, keep listening, keep sharpening my pencil.

I am in awe of the work of Helen Correll. I am inspired by the devotion that her work represents. I am smitten by her discerning eye and sure hand. But what attracts me most to her lovely notebooks, and what makes me most happy about the publication of this volume, is a certain spirit, a sprightliness, a holy whimsicality. As surely as a writer has a voice, an artist has an eye, and because Helen has both, illumination is the hallmark of her pages. This body of work has soul. Let it ground you.

Eastern blue star found on a sunny, spring day

TABLE *of* CONTENTS

Fall

Winter

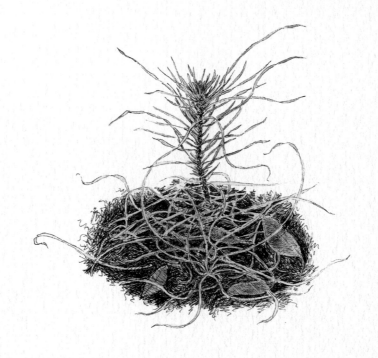

Spring

SNOW HOLES
march 6

*L*ast Sunday's dramatic thunder snowstorm is almost history, but not quite. In the deep, cold shade of pines around Middlewood, islands of melting snow can be found. I like to see the way the catbrier, rose, and grass stubbles warm and melt the snow around them, creating tidy little holes. Yesterday, the entire pipeline was covered in holey snow, and it wasn't just stubble, grass, and small stumps that I discovered. In one there was a dead meadow vole, five inches long with shiny gray/brown fur and hairless tail. He looked like he was just taking a nap. In another snow hole was a dead song sparrow.

Today there have been no unhappy surprises, and the snow is melting fast. The high was 70 degrees, and in the sun it felt even warmer. It was windy, though, so a fleece jacket felt good. Radu's hair blew straight up on his back and his ears flapped up in the stronger gusts. He didn't seem to mind. As usual, he waited patiently for me to finish drawing.

For the record, having thunder, lightning and high winds during a heavy snowstorm is quite strange. *FLASH! BOOM! Rumble, rumble.* I have never seen huge snowflakes in such abundance. We kept running out to the side porch where we could look straight up into the snow falling in the floodlight, then back inside to warm up by the fire and watch the snow pile up on the deck. However, power lines down and a three-day power outage was the price for all that beauty. So glad spring is coming on!

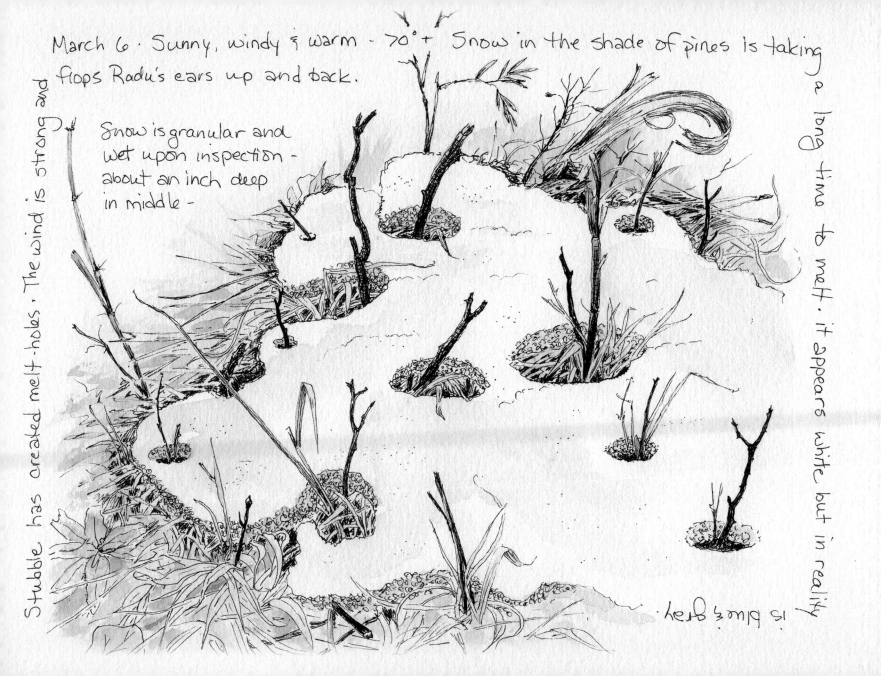

March 6 · Sunny, windy & warm - 70°+ Snow in the shade of pines is taking flops Radu's ears up and back.

Snow is granular and wet upon inspection - about an inch deep in middle -

Stubble has created melt-holes. The wind is strong and a long time to melt. it appears white but in reality is blue & gray.

Carolina Jessamine vs. Japanese Honeysuckle
march 14

*T*ook the dogs down to the banks of Lawson's Fork to see what early wildflowers might be blooming. Since the rue anemones are in flower in the protected little cove on Meetinghouse Creek, I assumed at least those flowers would be out. But as we wandered the shore along Lawson's Fork looking for blooms, we found none. Nevertheless, Daisy had a fine time jumping into the water, back up to the muddy bank, into the water, and back out again. Twisting mountain laurel trunks and branches and the arching limbs of dog hobble looked lovely in the gray haze of this pre-spring hardwood forest, but there were no flowers, no unfurling fern fronds.

On the way home I finally settled in the sun next to a pine to draw the woody vine of our official state wildflower, Carolina jessamine. The vine grew from the base of a pine and intertwined with invasive Japanese honeysuckle. The tangle gets even more involved as it curves around the other side of the tree, where coral honeysuckle joins the fray. A dogwood is in bud above it all, and at some point in April, all of these plants will be blooming together, all whites, reds, and yellows.

March 14th
. Bluebirds .

Late afternoon · partly cloudy with cooling breeze.
Mourning Doves.

Carolina Jessamine
near the base of a pine,
intertwined with
Japanese Honeysuckle.

about ½ inch
in diameter

Saw my first Tiger Swallowtail down by the river. Lots of

brown owl · Screaming Red-tail Hawks · Chickadees.

birds out today - Nuthatches · Red-bellied Woodpecker · Crows mobbing a huge

ASG

Round-Lobed Hepatica & Rue Anemone
march 18

I headed out today with a specific mission: to hike to my favorite little cove on the lower portion of Meetinghouse Creek and draw the round-lobed hepaticas that grow all along the edges, on both the east and west-facing slopes. The day was warm for March, 82 degrees, and even though there was a cooling breeze from the west, it passed high over my head as I sketched beside the creek, and the sun shining straight down on me made my head feel rather toasty. At the other end I was cooled by the damp, loamy soil revealed as I slid at a snail's pace downhill and scraped away the leaf litter, which allowed my jeans to soak up some of the moisture.

Hepaticas on the east-facing side of the creek grow on a steep bank of moss above the water. There are also dainty rue anemones, partridgeberry vines, and hundreds of violet-shaped leaves about the size of my pinky fingernail. Butterflies fluttered past as I drew: a tiger swallowtail, mourning cloak, spring azure, and three folded-wing skippers. A fat, black fly buzzed around for a while and had the nerve to land on me. While I drew, Daisy explored downstream, sniffing rocks and playing in the pools of water. She finally came back to lie on a big rock that jutted out above where I sat, her dainty front paws hanging over the edge as she fell asleep.

March 18 · Sunny and hot · Butterfly weather! Tiger Swallowtail ·

a nap.

Black fly lands on my knee →

fine white hairs along flower stems

Hepatica growing on a steep mossy bank alongside Meetinghouse Creek

Rue Anemone

Silvery splotches on leaves

also growing on mossy bank

Partridgeberry

Spring Azure · Mourning Cloak · Folded-wing Skipper · Lots of

Daisy takes / soothing gurgles · I sit make / below where / Waterfalls

Chickadees in the trees near the creek. Chick-a-dee dee dee! Small waterfalls

Liverwort, Zebra Swallowtails, & Northern Water Snake
march 24

The trick to seeing things is to go slowly. By creeping along the riverbank at a snail's pace today I noticed so much more than I had just yesterday. Blooming bloodroot and rue anemone were the main show, but there was also a lone purple Hepatica, sprays of dainty, white Carolina silverbells dangling from slender tree limbs, dwarf paw paw blooms, and an unidentified yellow composite. I saw a mating pair of sleepy duskywing butterflies, and a green anole advertising for a mate by showing off his beautiful red throat. Zebra swallowtails flitted along the riverside like it was a highway.

While I sat on the side of the river drawing the leathery ribbons of liverwort clinging to the wet clay banks of the river, I paused a minute to watch the water run past me. I was surprised to see a three-foot long northern water snake glide by with the current. The snake pulled up onto a sandbar just beyond where I sat and stuck his head out of the water to look at me. He turned and swam upstream a bit and then pulled back onto the sandbar to look at me again, this time for two or so minutes. Our eyes met. At last he slid back into the water and continued upstream, disappearing behind a big rock that jutted from the water. I kept watch, hoping to see him come out from behind the rock. For several minutes nothing happened, but finally I saw his head stick out, looking in my direction. *Is he interested in me*, I wondered, *or am I just in his space?* Whatever it was, I felt distinctly that he wanted me to leave.

March 24 · Sunny and cool · sitting beside Lawson's Fork in the afternoon sun · rushing over the shoals at Helen & Susan Islands.

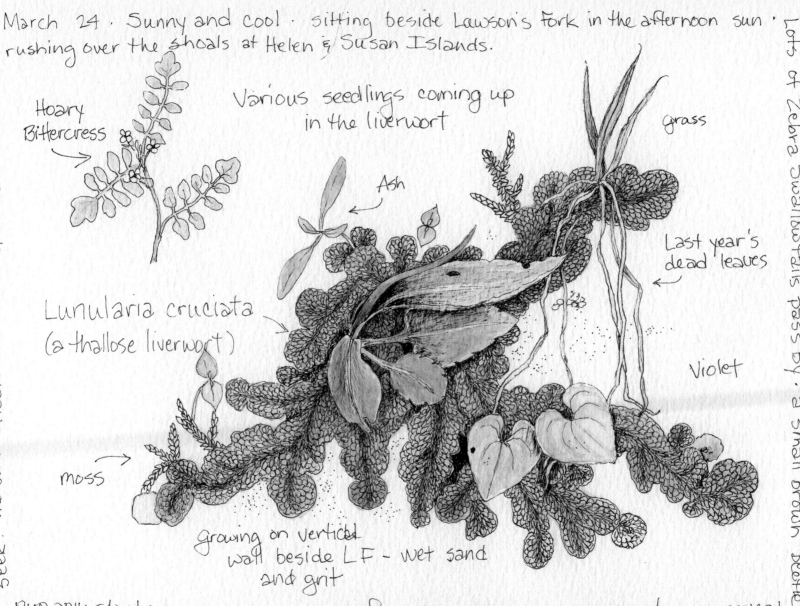

Hoary Bittercress

Various seedlings coming up in the liverwort

grass

Ash

Last year's dead leaves

Lunularia cruciata (a thallose liverwort)

Violet

moss

Growing on vertical wall beside LF - wet sand and grit

Seek! The sun reflects in a million sparkles off the water.

Lots of Zebra Swallowtails pass by · a small brown beetle lands on my shoulder · A water snake glides downstream than plays hide and

Spring Things
march 30

Headed out for a hike this afternoon with my journal and pen and two dogs. On the far sunny hill, with a warm breeze in my face, I found a tiny patch of bluets waving in the wind. Radu and Daisy were playing at a distance, so I put down my mat and sat to draw. One bluet bloom later I had a puppy in my lap and a big yellow dog nosing around in my bag for the treats I brought. I gave them both a peanut butter crunchy treat and they settled down a bit. I opened my pen. Immediately I had to fight off the tiny puppy teeth that wanted to chew on the pen-top. "No, Daisy," I said. Then she thought my journal would be a good chew. I dug around in my backpack and found a small beaver stick from one of my kayak outings. "Here you go, Daisy." She chewed for about two minutes and then got up to explore other things. Whew … a minute to draw bluets, cinquefoil, violets, grass … The next time I looked up there was no Radu, no Daisy, just silence. A Carolina wren started singing at the edge of the pipeline, a bee buzzed past my head. I looked up to watch a red-tailed hawk soaring over the creek. No dogs could be seen or heard.

I stood and called … and called and called … until little Daisy finally came through the woods from the direction of the high, rocky ridge. I let her climb in my lap and hugged her hard. As soon as Radu showed up we headed home. I was determined to finish my entry, so I put Daisy in the house, called to Radu and together we headed back out to draw in the woods. Radu, alone, did his usual patient snoozing and we both enjoyed the peace.

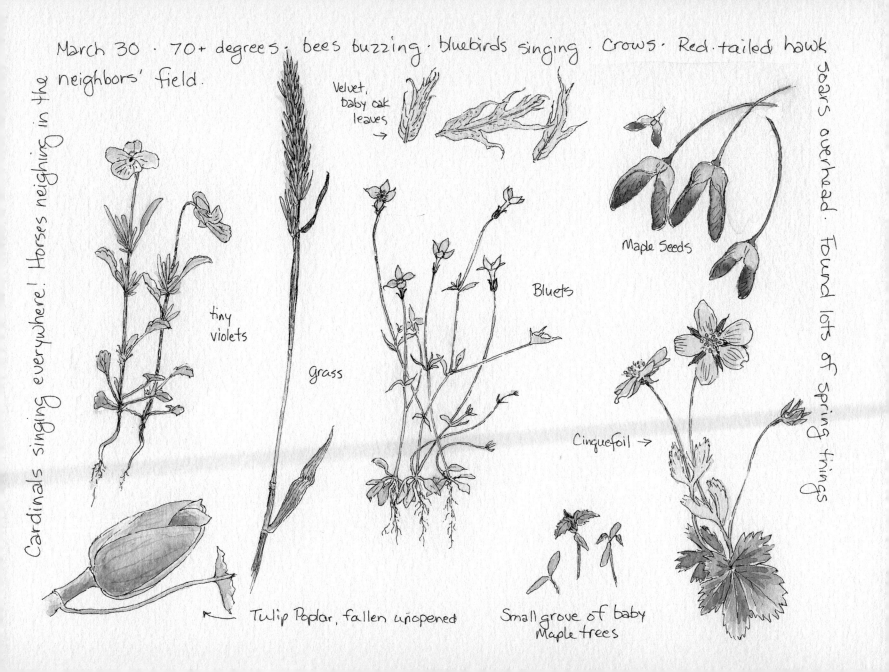

March 30 · 70+ degrees · bees buzzing · bluebirds singing · Crows · Red·tailed hawk soars overhead. Found lots of spring things

neighbors' field.

Cardinals singing everywhere! Horses neighing in the

tiny
violets

Grass

Velvet, baby oak leaves →

Bluets

Maple Seeds

Cinquefoil →

Tulip Poplar, fallen unopened

Small grove of baby Maple trees

THE UNFURLING
april 3

*T*his was the best kind of spring day: bright and sunny with white cloud puffs drifting across a deep blue sky. Temps in the mid-70s felt warm enough but not hot, and there was a soft breeze that made the pines creak as they swayed. All the trees are leafing out, giving the woods behind the house a soft, green haze. In bloom are dogwoods, redbuds, and Carolina jessamine. In song are crickets, wind through the pine boughs, lawn mowers in the distance, Carolina wrens, cardinals, chickadees, tufted titmice.

The dogs and I took a long hike and then came back to draw in our woods. I love it when Solomon's seal starts coming up here. Our variety is delicate, thinner than others I've seen. In spring they push up and unfurl their juicy green leaves, bright against the crispy brown carpet of winter. The birds were very noisy while I worked: cardinals, chickadees, mourning doves, Carolina wrens, titmice, and many goldfinches and purple finches chittered and sang throughout the woods. A noisy red-bellied woodpecker called with loud *kwirrs* and *chas* to tell me to watch him. Through binoculars his crisp black and white barred back and red head glowed against the gray trees and sky. The diffused light was just right to see his pale "red" belly, actually more pink-bellied than red-bellied. I watched him eat bugs from a tall white oak, in a section of trunk with many rows of holes made by yellow-bellied sapsuckers. Since the red-bellied woodpecker is known to store food in cracks and crevices of trees, I wondered if this bird had used some of the holes to cache food. I watched until I saw him pull something out of a hole. His food cache? My guess is yes.

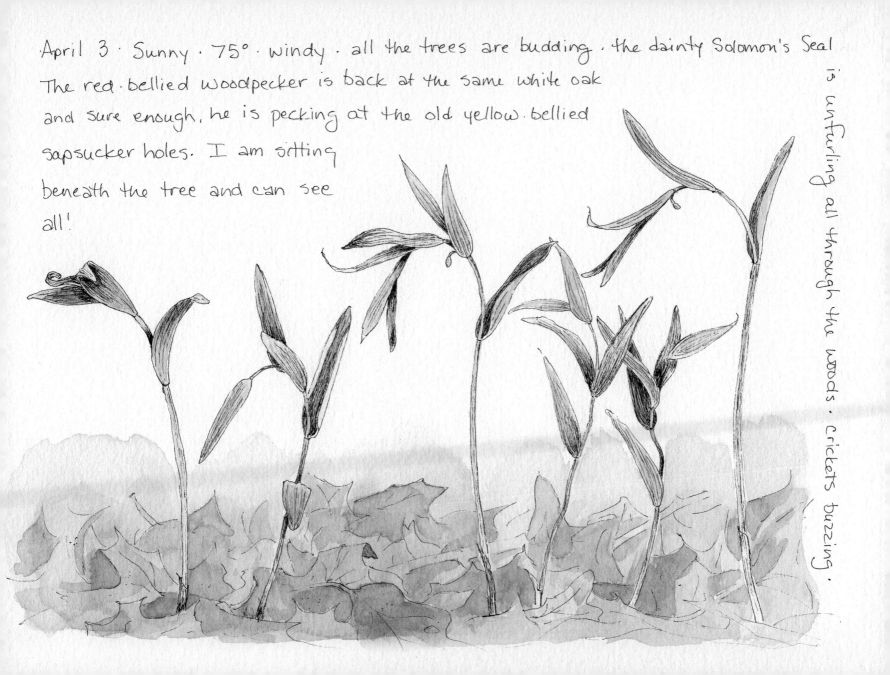

April 3 · Sunny · 75° · windy · all the trees are budding · the dainty Solomon's Seal
The red·bellied woodpecker is back at the same white oak
and sure enough, he is pecking at the old yellow·bellied
sapsucker holes. I am sitting
beneath the tree and can see
all!

is unfurling all through the woods · crickets buzzing ·

YELLOWROOT
april 8

*Y*ellowroot is in bloom down by Meetinghouse Creek! The small plants' woody stems hang out over the water, each topped with a burst of spring-green leaves and racemes of tiny purple flowers. When I look at them I am reminded of miniature fireworks, yet they are so subtle I've been known to walk right past them. I first learned about this plant from a pharmacist friend who had someone come into the store asking for *yellaroot.* Apparently the roots and stems of this plant were used by Cherokee Indians to make an herbal spring tonic and to heal everything from sores on the skin to stomach ulcers, and it is still used as a folk remedy. I recently saw a hand-painted sign for yellowroot tea tacked to a pine tree in the middle of nowhere, Georgia, on the way to see my parents. The roadside stand also sold moonshine jelly and frog jam.

I hiked down to draw one of the plants today under heavy skies that threatened to rain at any moment. I'd checked the radar before I left home, so I knew that time was short, but it was peaceful and cool and I had the rippling creek and a Carolina wren keeping me company. So although short, the time was sweet.

April 8 · Cool · Low clouds · Threatening rain · Sitting beside Meetinghouse
bursts into spring growth like fireworks.

Yellowroot dangling
over Meetinghouse
Creek —

Four red-tails
circle above

growing
out of
the bank

Woody stem

The main stem droops off the creek bank and

Creek to draw the Yellowroot that grows along the

bank · Too often I completely miss the short bloom-time of this plant

GREAT RED UPRISING
april 12

We've had a lot of rain lately, and a few warmish days, so I thought today would be good to hunt for mushrooms. I walked slowly and studied the ground in all the usual places. I took the path less taken … and the path rarely taken. I left all paths and headed into the damp, spongy-floored piney woods below the house. There are always mushrooms down there, but, no, not a single mushroom in any of those places. The wind jiggled the tiny, green maple leaves; hickory saplings were unfurling their small, fuzzy leaves; fringe trees were beginning to push out tasseled blooms; ironwood trees were leafing out. Mossy logs and pines downed during winter storms filled the piney woods, but there were no mushrooms.

I walked the full circle back to the studio and gave up the mushroom quest. Instead, I sat on my studio porch to draw a mayapple growing in a pot. While looking at it, by chance I focused beyond the plant and saw, four feet away, a beautiful red mushroom, the red cap and sturdy white stem just emerging from the ground. It had pushed away a thick mat of leaf litter, leaving a dark cave beneath that would make a great frog home. The red top was broken, possibly the result of a branch falling on it. The color had also "chipped away" in spots on top and along the edge, revealing the white under layer. A small black beetle landed on a leaf beside the mushroom. Daisy put her paws on my back and looked over my shoulder, and then she tried to sniff the mushroom. I distracted Daisy for a while with a stick to chew on, but just as I finished drawing the mushroom she walked over and sat on it.

April 12 · Sunny & Windy · occasional dark cloud with
studio. Before I finished drawing-Daisy sat on it...

maple tree · Red mushroom just outside

small black
beetle flew in
and landed while I drew.

thunder and a few sprinkles passing. then

sun returns · a tufted titmouse is singing from a small

MOSSY RIVERBANK
april 14

*T*oday I spent a couple of hours drawing on the mossy banks of Lawson's Fork. By the time the dogs and I hiked there it was midday. The sun, bright and strong, made all the tender spring leaves shimmer as they danced in the strong breeze. I'd felt warm while hiking in the sun, but beside the river there was only dappled light, and the open water allowed the wind to pick up speed, so it was definitely cool. While I worked, the dogs ran, jumped and splashed in the water, and nosed around Susan and Helen Islands. A tufted titmouse called *chiva! chiva! chiva!* from the limb of a dogwood tree full of showy white flowers. Beetles and spiders came to visit me. One spider looked like a miniature daddy longlegs. Zebra swallowtails fluttered through the woods—I counted five—as well as spring azures, sootywings, and pearl crescents.

Hundreds of violets (confederate and common blue), river oats, and various sedges and grasses grow in mounds of moss along this stretch of river. I followed a well-used wildlife trail through them, down to the very edge, where I could touch the water if I wanted. Just downstream the arching branches of dog hobble were in bloom, and a few rue anemone still held delicate white flowers. Other plants were sprouting beside the river but not yet in bloom: euonymus, Virginia creeper, ginger, as well as trillium, Solomon's seal, and maple-leaf viburnum. As usual the dogs spent most of their time in the water. They stirred up a small water snake that swam away with lightning speed and disappeared. The soggy dogs did not find the snake again. They curled up near me for a long nap as I drew.

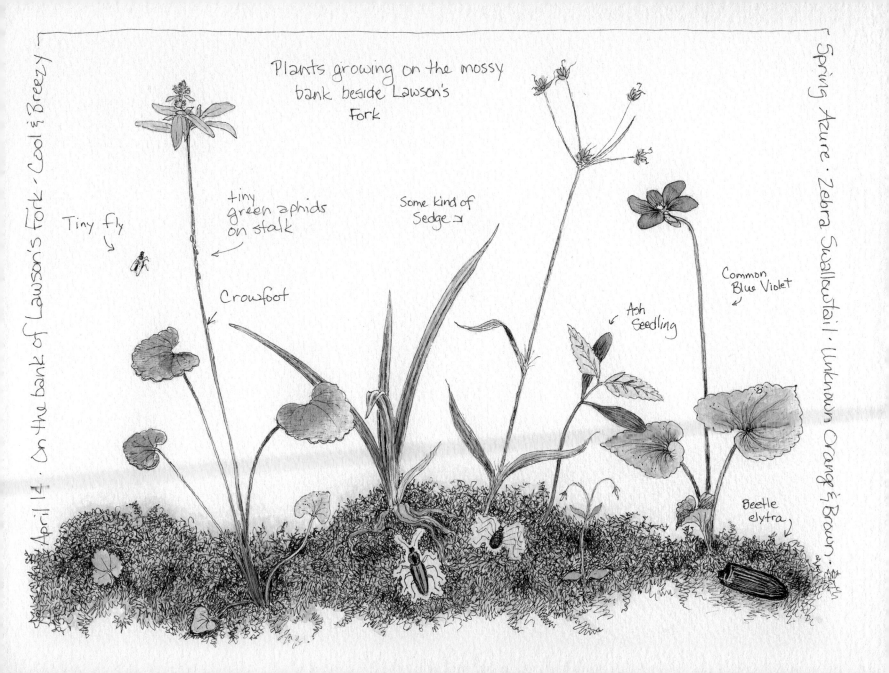

Plants growing on the mossy
bank beside Lawson's
Fork

Tiny fly

tiny
green aphids
on stalk

Some kind of
Sedge →

Crowfoot

Ash
Seedling

Common
Blue Violet

Beetle
elytra

DWARF CRESTED IRIS
april 15

The weather cleared around 3 p.m. today, and I went out to smile at the sun. I found that the rain had brought out many spring things, the first being tiny leaves. A tiger swallowtail sipped at the profuse blooms of purple creeping phlox draped over the rock wall, and bleeding heart and wild blue phlox were opening their spring show in the front woods. There were so many birds singing all around it sounded like an aviary: Carolina wrens, chickadees, goldfinches, cardinals, tufted titmice, pine warblers, white-breasted nuthatches, purple finches, and more.

Dwarf crested irises grow around a rock outcrop in the woods below the house. When they bloom, it's an amazing sight—if I don't miss it. Some years I get busy and forget to go look. Today I walked down to see if they were blooming and found that they are just beginning their season. The bud I drew was the only purple to be seen, but by the time they are in full bloom it will be a glorious sight. I sat down to draw and enjoy the birdsong, the dappled sunlight, and the warm breeze through the spring trees. The dogs were in the house so I was alone. A fuzzy brown caterpillar crawled across my knee … a tiny grasshopper landed on my shoe … a brown and black beetle flew into the leaves beside me. Otherwise, not much was happening at Middlewood today.

April 15· End of the afternoon· clear· sunny· 70°· ground wet after morning rain·
and tiny grasshoppers have passed by...

tiny grasshopper
hopped around
on leaves

Dwarf Crested
Iris
(about to bloom)

CAW! CAW! CAW!

Birds are everywhere! Sounds like an aviary· Cardinals· Finches· Carolina Wrens· Goldfinches in summer plumage· Titmice·

Pileated woodpecker· Red-bellied woodpecker· Caterpillars

Lance-Leaf Coreopsis, Southern Ragwort, & Daisy Fleabane

may 5

While hiking today I couldn't help but admire the early May beauty of the pipeline. The coreopsis is prettier this year than ever, or at least the prettiest I've seen it in twenty-one plus years of living out here. I found other flowers blooming with the coreopsis: lyre-leaved sage, gray beardtongue, bull thistle, white yarrow, spotted cat's ear, and daisy fleabane is just beginning to open. Downhill, the scent of honeysuckle lingered in the valley of Meetinghouse Creek, where morning-cool air still swirled and the clay track was soft and wet.

As I walked, grasshoppers (Carolina locusts) leapt out of my way, and occasionally one would leap back into me. They hit my arm, my chest, my thigh, and one leapt straight into my face and smacked me in the eye. I felt like I was under attack! Besides grasshoppers, there were dozens of dragonflies zipping around—four-spotteds and green darners—and butterflies: tiger swallowtails, buckeyes, azures, painted ladies, monarchs, and more (unidentifiable) in the distance. It's such a joy to see these beautiful insects visiting the various blooms.

The dogs and I settled in the sun to draw flowers. It was quiet until the breeze kicked up and rattled the cottonwood tree just up the hill from where I sat. It sounded so much like rain on the leaf-litter that I immediately looked to the sky to see where the drops were coming from. No clouds? I twisted around to look behind me and saw the cottonwood leaves wiggling in the breeze and making a soft rattle. I had to smile. Birds I saw today: rufous-sided towhee, pileated woodpecker, chickadees, cardinals, Louisiana waterthrush in the woods by Meetinghouse Creek, kinglets in the pines.

May 5 · Sunny · cool · breezy · Lots of Butterflies out today · Buckeyes · Great Spangled Fritillaries · American Painted Ladies · Tiger Swallowtail · Daisy Fleabane · Spring Azure · Monarch · Clouded Sulphur · Pearl Cress · Grasshoppers jumping from grass as I walk ·

Drink-your-Tea!!!

The Cottonwood tree on the hill
above me rattling in the breeze
sounds like rain pattering on
the leaves in the woods - Also
many calls of Rufous-sided Towhee -

Buds reddish-brown is calyx

open calyx

Elytra from Fiery Searcher

Lance-leaf Coreopsis

Southern Ragwort

Four-spotted dragonflies zipping around

A Grasshopper leapt from grass and hit me in the face!

Daisy Fleabane

Biotite Mica & Other Black Things
may 6

We had spring rains today. Storm after storm swept over us, drenching every tree, rock, and blade of grass. The sun would shine for a few minutes and tease me into believing it was over, only to cloud up again and *BOOM boom boom* … another gullywasher.

The dogs and I took a quick hike between two storms. I had my binoculars with me in hopes of seeing the indigo buntings that sing so sweetly in the trees along the pipeline. Sure enough, they were there. I heard them singing but couldn't see them. I tried going uphill and looking down, looking straight up from underneath the tree, then I went downhill a bit and looked back. No luck. They were not on their usual perches, a bare branch at the tip-top of a tree. Or, if they were, the trees were too far back in the woods.

We turned back before we even got to Meetinghouse Creek because it started drizzling again. On the way I found a crow feather, solid black against sandy clay. A little further on I found a dead beetle on the path, with ants snacking on the edible parts. The two hard, shiny elytra (hardened forewing) had been cast aside and had no ants, so I picked them up. The turkey feather came next, delicately balanced on spikes of spring grass.

Back at the house I noticed the last gullywasher had washed some chunks of our gravel drive onto the brick walk. On the second step sat a piece of white quartz with a thin layer of biotite mica. Daisy wandered up and found a dead wasp on the edge of the walk. I moved the wasp from her sight so she wouldn't eat it, and, reaching behind me to put it with my other goodies, I realized that they all had something in common: the color black.

May 6 · Rain · Rain · Rain · Thunder · Gullywasher · Quick my head. Startled some crows!

Quartz w/ Biotite Mica

crunched wing

dead wasp

Thin Shiny Sheets

Crow feather

(Left the Beetle body for the ants)
Beetle wings

Downy-soft "barbs"

outside - glossy black

inside - reddish brown

Turkey feather in sand

Indigo Buntings singing in the trees above

Hike with the dogs between storms · Picked up black things that caught my eye to draw at home.

BEARDTONGUE & RAGWORT
may 9

The weather was warm and windy today, with gusts strong enough to bend the pine treetops. I wandered on the pipeline looking for a patch of mushrooms I saw yesterday, and as I stood gazing down at the spot where I thought they'd been, a big shadow passed over me. Glancing up I saw a huge red-tailed hawk just as he landed in a nearby pine. The small oak growing in front of the pine had a hole in the branches that framed the hawk perfectly as he preened and fluffed himself. He was so close I could hear little noises and flutters of wings as he balanced and adjusted his stance. His rusty-red tail glowed in the sun. I admired him until he finally saw me and flew off his perch with a loud flap. The strong wind buffeted him as he flew across the pipeline. It made his flight quite ungraceful.

While I was drawing beard-tongue flowers, a newly emerged red-spotted purple butterfly wobbled out of the woods and landed on my backpack. His shimmering blue and black patterned wings with spots of red were gorgeous. He rested a minute then fluttered up and over about five feet and landed again. The butterfly made these short flights over and over. I followed him downhill until he finally warmed up and took off over the pipeline's waving grasses and wildflowers to disappear in the pines on the far side.

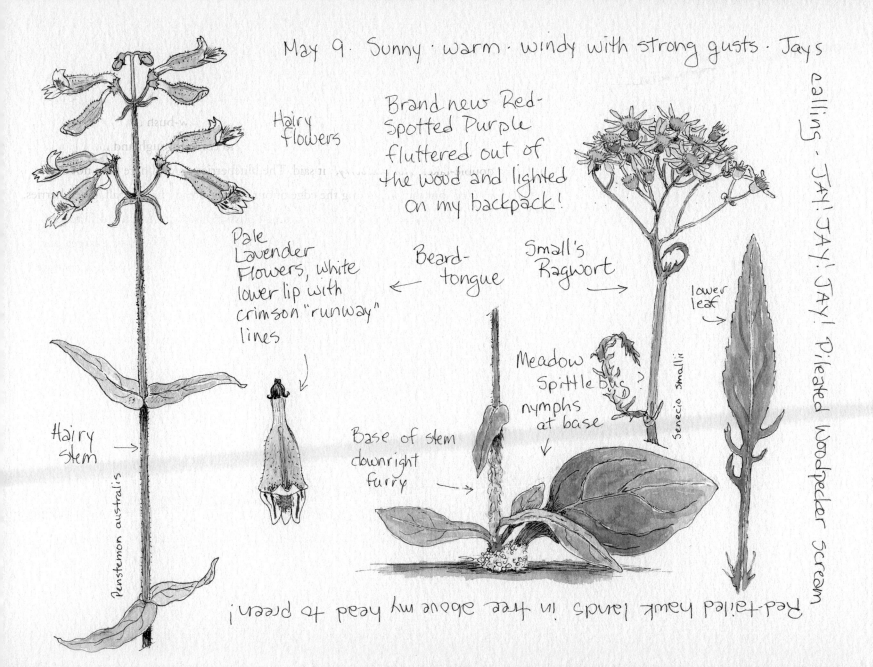

May 9 · Sunny · warm · windy with strong gusts · Jays

Hairy flowers

Brand new Red-Spotted Purple fluttered out of the wood and lighted on my backpack!

Pale Lavender Flowers, white lower lip with crimson "runway" lines

Beard-tongue

Small's Ragwort

lower leaf

Hairy Stem

Penstemon australis

Meadow Spittlebug nymphs at base

Base of stem downright furry

Senecio smallii

calling · JAY! JAY! JAY! Pileated Woodpecker Scream

Red-tailed hawk lands in tree above my head to preen!

DEERBERRY & PERSIMMON
may 16

As I headed up the steep cut that runs between clearings, I saw a low-bush blueberry blooming, and ticked it off on the list in my head for today: Lance-leaved coreopsis–check, pasture rose–check, toadflax–check, low-bush blueberry–check … it took about two seconds for my subconscious to come through and make me do a double-take. "*Not blueberry,*" it said. The blueberries around here have not only bloomed, but the ones along the edge of our woods already have small, green berries. I turned and walked right back to the small bush to study it. Another difference was the size and shape of the open, dangling white blooms. These were larger, and even though the buds were "bell-shaped," the fully opened flowers were open wide, almost flat. Fully opened blueberry blooms are still little bells. I snapped off a short piece of a flowering branch and took it home to identify. Turns out it was deerberry, in the vaccinium family, first cousin to the blueberries. To make sure, I walked back with my field guide.

Coming home, I passed a tree with many small blooms along the stems at the base of the leaves. Persimmon? I looked it up, but the small blooms didn't fit the description in the field guide as being 5/8" wide, and solitary. Solitary? These blooms were bunched in threes at the base of the leaves and none of the many blooms were any wider than about 3/8". The mystery continued until I read far enough into the detailed description to learn that it is the female persimmon tree that has the solitary 5/8" blooms, while the male persimmons have flowers that are "bunched and only 3/8" wide." Okay. It's a male/female thing. Mystery solved.

new growth →

older stem

low-growing bush
on pipeline

outer growth
larger, more
tender →

Deerberry
Vaccinium stamineum

reddish blush to
newest leaves

reddish
petioles

unopened
flowers
green at
tips

yellowish
3/8" flowers

seen end-on
(enlarged)

Persimmon Tree
(Male) on Old
Thompson Rd.

PASTURE ROSE, BUTTERFLY WEED, & OTHER MAY WILDFLOWERS

may 27

It's been a funny kind of day—warm and humid, the sun in and out, and a while ago a band of showers passed by and chased me inside. I'd been checking out wildflowers on Old Thompson Road, if you can call it a road. There never was pavement, and the old roadbed is washing out into a small gully. Honeysuckle grows thick and is in bloom back there, so the air today was heavy with its scent. Many non-native flowers bloomed along the road: Venus' looking glass, oxeye daisy, English plaintain, queen ann's lace, as well as Carolina cranesbill, yellow wood sorrell, spotted cat's ear, and common fleabane. Out in the pipeline near our bench were pasture rose, butterfly weed, coreopsis, batchelor's button, and daisy fleabane. New Jersey tea shrubs were covered in dainty white blooms.

In our woods near the road were white milkweed, euonymus, and dainty summer bluet. A yellow-billed cuckoo called from above, making the steamy morning seem more like a jungle in Africa than the piedmont of South Carolina: *ku ku ku ku, ku ku ku ku, KALP! KALP! KALP!* he sang. Our resident wood thrushes sang their lilting watery song as well. Butterflies: great spangled fritillaries, eastern tailed blues, red spotted purples. I was lucky to see a wild turkey tom strut across the old roadbed and disappear behind low-growing briers, into our woods.

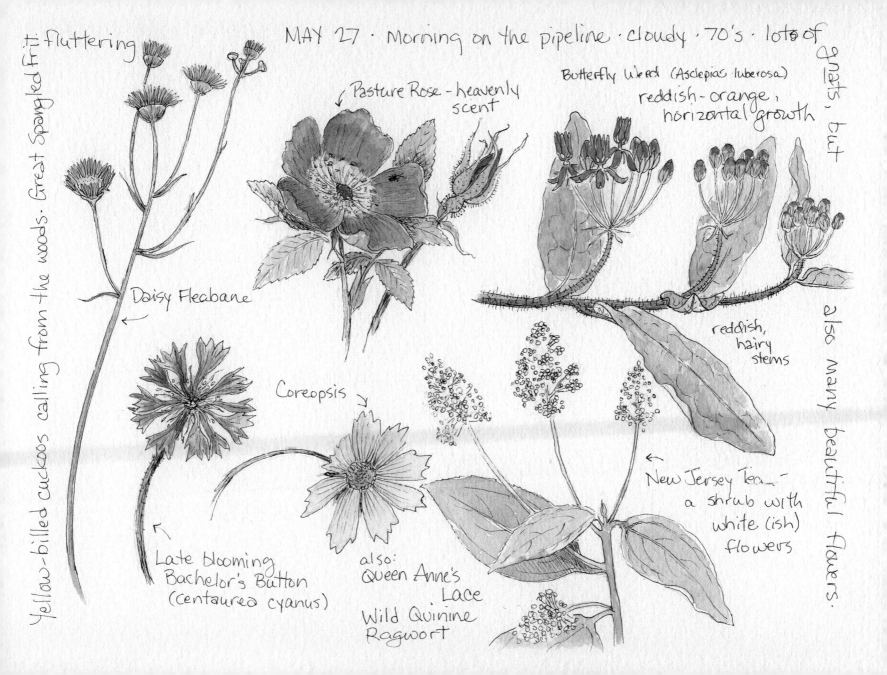

fluttering

MAY 27 · Morning on the pipeline · cloudy · 70's · lots of

Yellow-billed cuckoos calling from the woods. Great Spangled Frit.

Pasture Rose - heavenly scent

Butterfly Weed (Asclepias tuberosa)
reddish-orange, horizontal growth

gnats, but

Daisy Fleabane

reddish, hairy stems

also many beautiful flowers.

Coreopsis

New Jersey Tea – a shrub with white(ish) flowers

Late blooming Bachelor's Button (Centaurea cyanus)

also:
Queen Anne's Lace
Wild Quinine
Ragwort

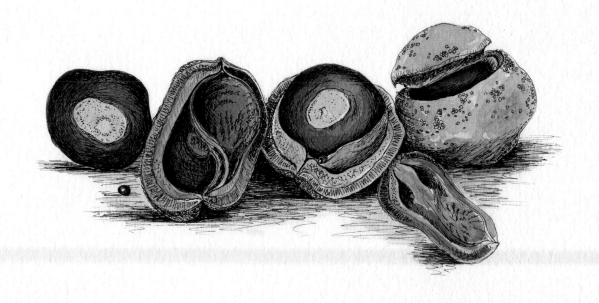

Summer

KIDNEY-LEAF ROSINWEED
june 1

A wild creek in June is a magical place to visit, and today Meetinghouse Creek was definitely that. I stopped by this morning and at first thought nothing was happening. Then I heard a low buzz, and a whitetail dragonfly zoomed in and landed on a reed, making it bounce and wave. A spring azure flitted down from uphill and sipped in the wet sand along the creek's edge. Minnows made themselves known by swimming through a patch of sunlight at my feet, and once looking for them I saw they were everywhere, swimming oh-so-leisurely and then darting off. *What's the hurry?* Four small, round sun-spots on the creek bed showed the whereabouts of a water-strider as he walked around effortlessly on the water's surface. His actual body was barely visible.

As I studied the water strider I became aware of something else, something that reminded me of how important it is to stop and settle into a place. Along the creek bottom, as clear through the creek water as on land, ran deep turkey tracks, heading downstream. What a fun discovery! I could imagine a lone Tom strutting along in the foggy morning, getting his fill of insects, spiders, frogs, and tender grasses.

On the way home I saw a blue darner dragonfly zipping back and forth over a sea of yellow coreopsis blooms, checkerspot and sulphur butterflies, seven black vultures circling. I heard chickadees' and indigo buntings' songs. At the top of the hill were the new leaves of kidneyleaf rosinweed, the most beautiful native plant leaf growing around Middlewood. The leaves are large and ornate. The fall-blooming flowers are small yellow composites on very tall stems and a good source of nectar for butterflies. As I admired the bright leaves, a cloudless sulphur butterfly landed on one.

Spotted Cat's Ear & Mockingbirds

june 2

I love mockingbirds. On my hike this morning I heard one singing from a tulip poplar. He seemed to be quite full of himself, singing everyone else's songs. I walked toward the creek on the cool, shady side of the pipeline and enjoyed his music, as well as the *chirrrr* of field crickets, the buzz of bees, a yellow-billed cuckoo's monkey-like call, the clear notes of cardinals, and chickadees. Scents of summer were everywhere. One spot was heavy with a musky sweetness I couldn't identify.

I explored along Meetinghouse Creek, where eastern tailed blues drank from the sandy edge of the stream, and a great spangled fritillary sipped nectar from butterfly weed. White yarrow is blooming, and horse nettles, too.

Back at the crest of the hill the mockingbird still sang. A delightful steady breeze blew from the south, so I sat down to draw Spotted cat's ears that grow there. While I drew, many small spiders visited me, either creeping tentatively across the page or dashing so quickly I thought perhaps I'd imagined it. A tiny black beetle came to check out my drawing—walking, stopping to look around, walking, stopping. A cricket landed on me. A folded-wing skipper lit on the bloom I was drawing, sipped, and was gone.

As I finished my drawing the mockingbird stopped singing. Oh, the peace! I remembered that once I compared a mockingbird to a loud radio with a child at the knobs constantly changing the stations so that you heard snippets of songs but none of them completely through. Other birdsongs drowned out by the mockingbird could now be heard: indigo bunting, red-bellied woodpecker, tufted titmice, and the soft *zeeeeet!* of golden-crowned kinglets from high above me in the pines.

June 2 · early morning on the pipeline · a Mockingbird sings loudly from the woods ·
tiny spiders · gnats · flies · ants ·

Kinglets high in pines
Butterflies:
 Eastern Tailed Blue
 Silver Spotted Skipper
 Great Spangled
 Frit

tiny black
beetle

spider

shriveled
bud

flat,
blackened
stem

Purply-brown
Stripes on
back of outer-
most petals

← turns to
tan

gradually
to green

tiny scale-like
leaves

Spotted Cat's Ear

gnats!

Indigo Buntings · Chickadees · Tufted Titmice · Mourning Doves · Red-Bellied Woodpeckers · Pw · Cardinals · Not far away is a swarm of bees · high · up · loud · hum · Yellow-billed Cuckoo · a multitude of

Things Growing on a Mossy Bank
june 5

*D*aisy and I hiked up to the rocky ridge above Lawson's Fork today. Along the trail on the north-facing slope above the river we passed a black racer, twisted and curled in the middle of the path. A little further down, rattlesnake weeds, once thought to be a cure for the bite of a rattlesnake, were in bloom. The fuzzy basal leaves with deep purple veins are interesting enough on their own, but in early summer, when they send out their blooms on tall, wiry stems they become quite stunning. Of all the plants I saw, this was the one that appealed to me. It grew in a long mat of cushion moss, on the upper side of the trail as it heads down the side of the ridge. The plant was small enough to fit on my page, and came with interesting neighbors. In fact, the little group looked like it belonged in a terrarium.

I sat quietly and drew in my journal while Daisy explored the woods. I could just hear Lawson's Fork as it rushed over rocks near little Helen and Susan Islands. A downy woodpecker flew in and pecked at a tree just above me. He made no noise while he ate insects from the tree bark, but then he finished and sang out with the downy's rolling whinnies and soft *queek! queek!*

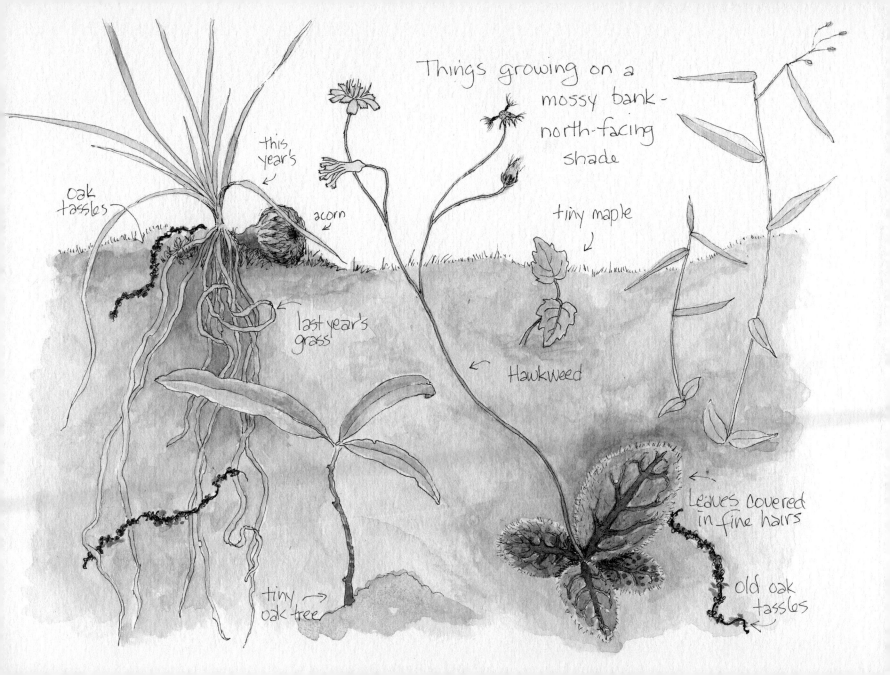

Things growing on a
mossy bank -
north-facing
shade

oak
tassles

this
year's

acorn

last year's
grass

tiny maple

Hawkweed

tiny
oak tree

Leaves covered
in fine hairs

old oak
tassles

CREEKSIDE: EARLY JUNE
june 7

This morning felt cool and fresh, and a breeze blew from the east as I headed downhill toward Meetinghouse Creek. There were no gnats swarming around my head, a big plus in summer, and there were new blooms to admire. Lacy white flowers covered New Jersey tea bushes, more than I ever remember seeing, and the delicate blooms of Clematis viorna dangled from low growing vines along the forest edge. I spotted a few late coreopsis blooms throughout the pipeline grasses and leaves.

On the way downhill I found some interesting mushrooms—one patch of intense orangey-yellow ones, and a white one still in button stage. I also found a dead luna moth lying flat on the path. It had been there through some rains, as it was still whole, but its pale green wings were already partially disintegrated where Mother Nature was doing her job of breaking the moth down and turning it into earth.

There was much activity around the slow-moving Meetinghouse Creek. Bees, beetles, and ants, as well as dragonflies, damselflies, and butterflies, buzzed, hummed, and clicked all around me. The most beautiful of all was the male black-winged damselfly that flitted about and landed in front of me. I think he wanted to show off his shocking turquoise color, one not often found in nature. When he rested on a leaf I could see that it wasn't just his long tail that was colorful, his body and head were covered in shiny turquoise plates, like a suit of armor.

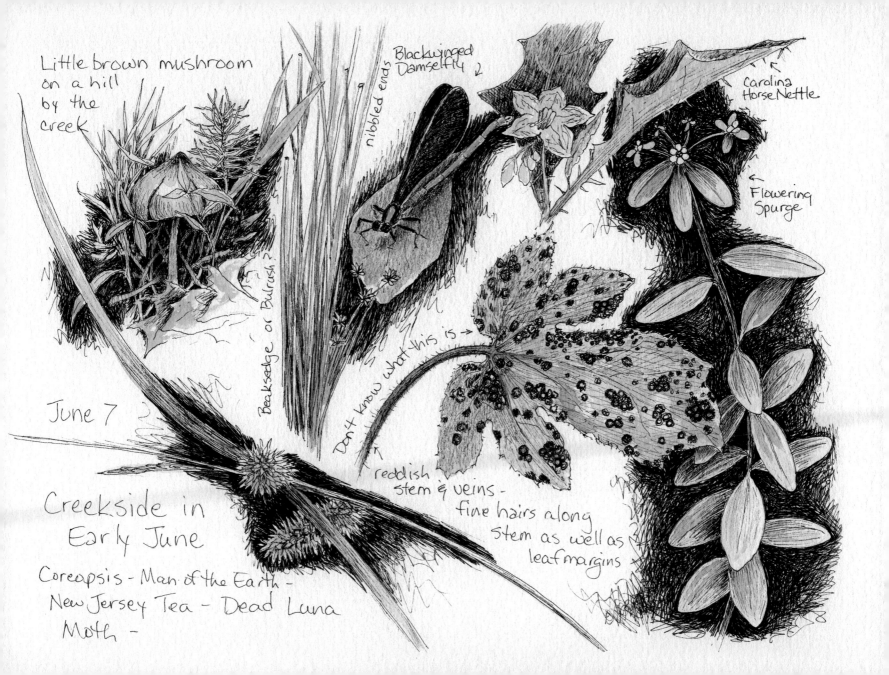

Little brown mushroom on a hill by the creek

nibbled ends

Blackwinged Damselfly 2

Carolina Horse Nettle

Flowering Spurge

Beaksedge or Bulrush?

Don't know what this is →

June 7

Creekside in Early June

reddish stem & veins — fine hairs along stem as well as leaf margins

Coreopsis — Man of the Earth — New Jersey Tea — Dead Luna Moth —

MEADOW BEAUTY & HORSE NETTLE

june 10

Today I headed out early to beat the heat that has baked the Upstate for weeks now. The sun was barely up and cardinals near our feeders were singing their hearts out. On the hill, indigo buntings sang from the tops of forty-year-old pines. Beginning around early May, I've seen the male indigos arrive from South America and perform all day from a high, bare branch to attract a mate.

On our trek down to the creek we heard several deer in the woods cough, warning each other that we were nearby. Naturally, Daisy took off like a rocket to find them. If only the deer would stay quiet, we would pass by without noticing them.

Close to the creek, where there is deep shade most of the day, the sand is still damp from a thunderstorm we had last Sunday. Embossed in the sand are long trails of both deer and turkey tracks, woven together in clear, fresh prints. A shallow, scratched-out spot in the sand showed where turkeys had taken a sand bath.

I settled in the middle of the dirt path near the creek to draw the horse nettle and meadow beauty that grow in the damp sand. Tufted titmice and chickdees, busy in a pine nearby, were talking with numerous *zeeeeets* and *chivas,* a typical soundtrack for my summer wanderings. It wasn't long before a brown thrasher began his mocking song, and yellow billed cuckoos started up their monkey calls all around. A crow cawed from the woods on the hill. Cicadas buzzed in the trees, a tip that the day was heating up.

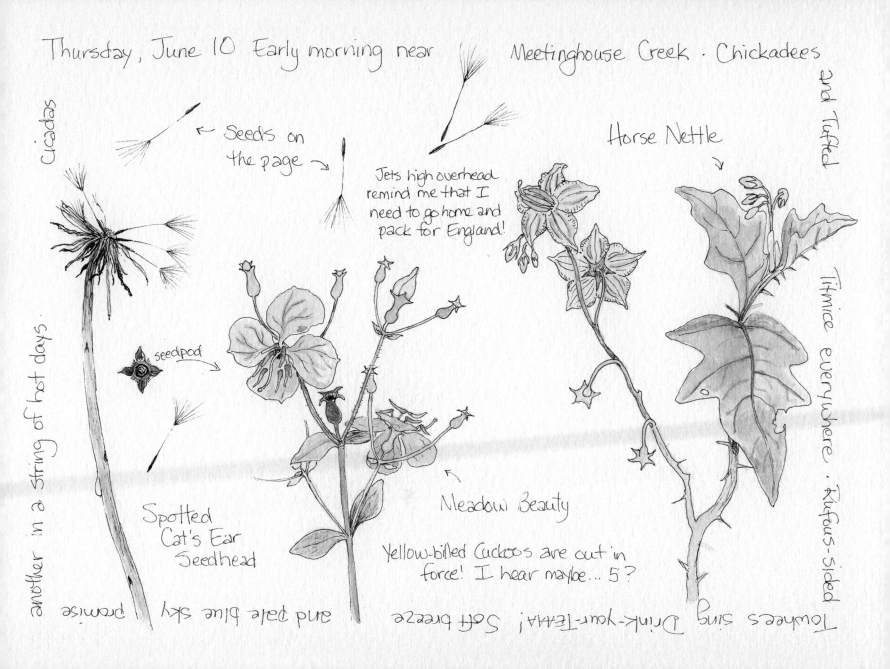

Thursday, June 10 Early morning near Meetinghouse Creek · Chickadees

Cicadas

another in a string of hot days ·

Seeds on the page →

Jets high overhead remind me that I need to go home and pack for England!

Horse Nettle

and Tufted

Titmice everywhere · Rufous-sided

seedpod →

Spotted Cat's Ear Seedhead

Meadow Beauty

Yellow-billed Cuckoos are out in force! I hear maybe... 5?

and pale blue sky · pure promise

Towhees sing *Drink-your-TEA-A-A!* Soft breeze

Ruellia, Meadow Beauty, & Carpenter Bee

july 5

After weeks of hot, sunny mornings, today's fog and cool temps were an invigorating change. Daisy and I headed out early to enjoy it. Birds were everywhere! Our resident indigo buntings sang in the pines along the edge of the woods, and blue jays called *jay! jay!* Mourning doves cooed, and chickadees and tufted titmice went about their seed-gathering with much chatter. We hiked down to Meeting-house Creek with a damp breeze in our faces, to where various flowers flourish in the damp soil: ruellia, meadow beauty, butterfly pea, as well as Queen Ann's lace, sensitive brier, and Joe Pye weed that has been nibbled by deer. Man-of-the-Earth flowers glowed like tiny moons in the fog.

I sat near the creek to draw ruellia blooms. Nearby grew a nice patch of meadow beauty with several species of bees around it, each buzzing at different frequencies. While I scritch-scratched on the page, my favorite bird, a wood thrush, started singing in the woods. Yellow-billed cuckoos called, and crows talked to each other in the distance.

Daisy passed the time by investigating the woods near where I sat, and chasing a deer that coughed and gave itself away. It was still only in the mid-70s when we headed home. Fog still surrounded us as we trudged up the steep hill, both of us looking a little worse for wear. The fog had turned my hair to a damp, wavy frizz. Daisy, already wet from running through the drippy forest and fields, collected twigs, broken vines, and leaves in her tangled collie coat.

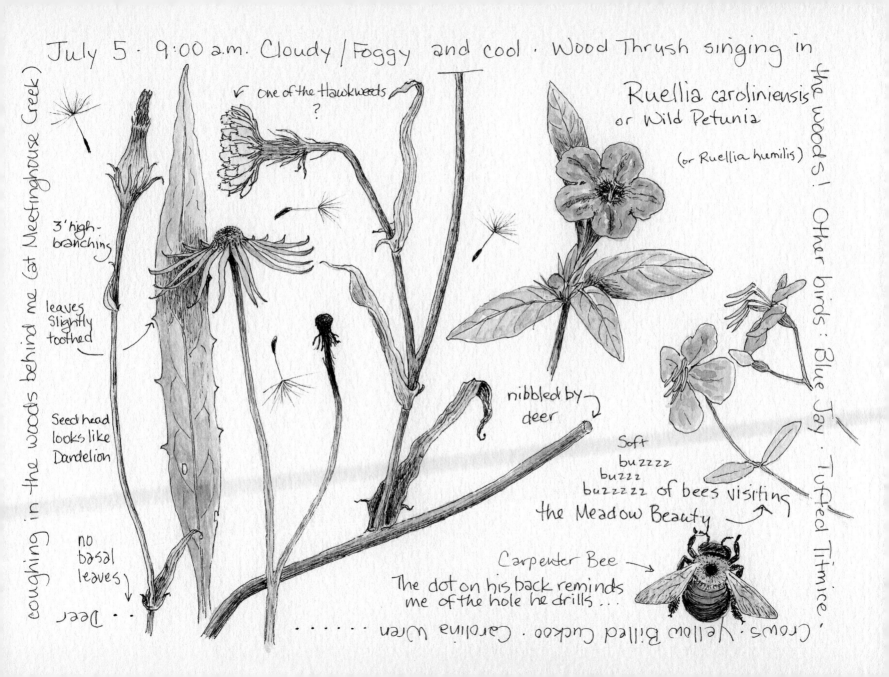

July 5 · 9:00 a.m. Cloudy / Foggy and cool · Wood Thrush singing in

Ruellia caroliniensis
or Wild Petunia

(or Ruellia humilis)

↙ one of the Hawkweeds
?

3' high-
branching

leaves
slightly
toothed

Seed head
looks like
Dandelion

no
basal
leaves

·· Deer

nibbled by
deer

Soft
buzzzz
buzzz
buzzzzz of bees visiting
the Meadow Beauty

Carpenter Bee →
The dot on his back reminds
me of the hole he drills ...

coughing in the woods behind me (at Meetinghouse Creek)

the woods! Other birds: Blue Jay · Tufted Titmice ·

Crows · Yellow Billed Cuckoo · Carolina Wren · ········

DWARF PAW PAW
july 24

A front passed through yesterday, and although I saw storms all around and heard much thunder, Middlewood did not get a drop of much-needed rain. However, the cool, dry breeze this morning was perfect for a hike.

I found two small down feathers at the furthest end of our pipeline. They are very soft … not sure what bird they're from. Rufous-sided towhees called to me all along the way, *"Drink-your-teaaaaaa!"* Cicadas clicked away in the treetops.

Hiking the hills felt so good I didn't stop to draw until I was in the woods coming home, when I passed by one of our hundreds of dwarf paw paws and was excited to see a single fruit dangling from a limb. Our little paw paws have plenty of flowers in the spring, but not so many fruits. I decided to draw it.

To get a good angle for sketching I had to sit on the ground so that I was eye-level with the fruit, which dangles beneath the leaves. This was a great set-up for about … hmmm … two minutes. Then the breeze died and the insects found me. *Buzzzzz* went the bees, *whine* went the mosquitos. Gnats showed up to flit around my eyes and ears. Flies buzzed around and around in circles somewhere behind where I sat. They weren't bothering me directly, but I could hear their constant noise as they flew closer, then further away … *bzzzzzzzzz ZZZZZZZZ zzzzzzzz ZZZZZZZ zzzzzzzz*. I slapped at mosquitoes and scratched their bites; spiders and beetles scritched around in the leaf litter. All in all, it wasn't a wonderful day to be journaling outside, but I persevered. This drawing is a labor of love, no doubt about it.

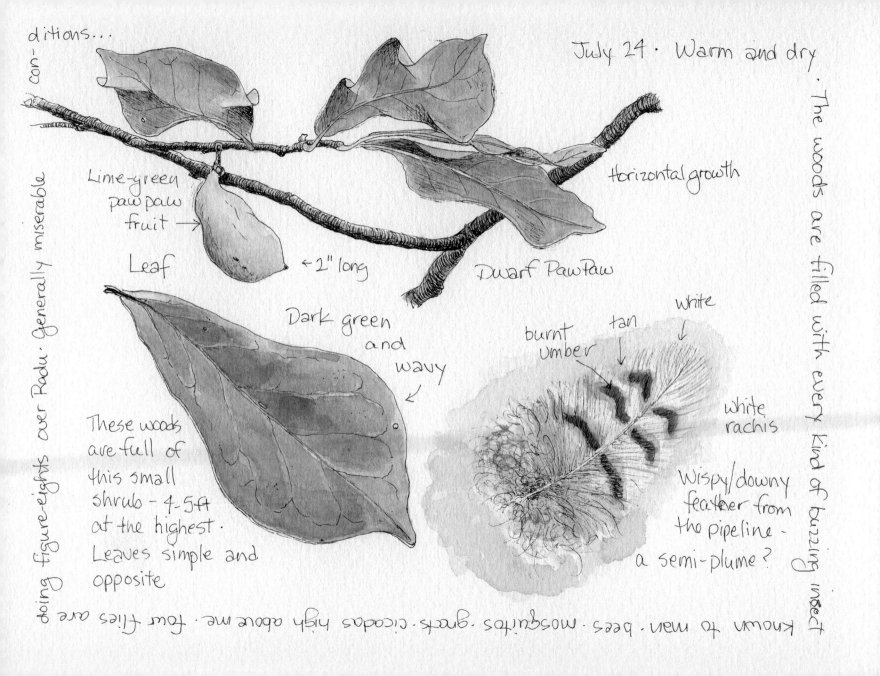

ditions...

July 24 · Warm and dry

Lime-green pawpaw fruit →

Horizontal growth

Leaf

← 2" long

Dwarf PawPaw

Dark green and wavy

burnt umber tan white
↓ ↓

white rachis

These woods are full of this small shrub – 4-5ft at the highest. Leaves simple and opposite

Wispy/downy feather from the pipeline – a semi-plume?

· The woods are filled with every kind of buzzing insect

con- doing figure-eights over Radu · generally miserable

known to man · bees · mosquitos · gnats · cicadas high above me · few flies are

Hickory Nuts & Eyed Click Beetle
july 28

Agentle breeze blew down the pipeline this morning, while blue skies towered above. It was quiet except for the high buzz of cicadas in the trees. I was poking around at the edge of the woods comparing the different kinds of thoroughwort that grow there when I noticed two hickory nuts snuggled in the messy tree stuff (a highly scientific term) under a pine tree. A squirrel obviously brought the nuts here to eat and left the empty "containers." I settled down to draw them.

While I worked I heard a sudden *bzzzzzzz!* and *BAM* a huge beetle flew into my leg and dropped onto the pad I was sitting on. I recognized him immediately as a friendly eyed click beetle. I'd seen one before. The huge "false eyes" had fooled me way back when, until I looked him up in a field guide. He is scary looking if you think those eyes are real. Today, since I knew he was just a fake and not at all dangerous, I stayed cool and calm and began drawing him. He was still for a while, and then started slowly walking away from me. I moved him back three times while I drew him. He finally marched into the dry, fallen leaves of the woods.

Two northern flickers flew into a nearby tree and called their funny *roika! roika!* They pecked around a while, and then flew on without further comment.

The bright yellow of a tiny poplar leaf popped out from the drab colors of the forest floor where I sat. It was such a happy color I wanted to add it to today's page as a reminder that days are getting shorter and we are moving towards fall, with its cooler days and longer shadows.

Tuesday · July 28 · Morning on the pipeline · Breezy and warm ·

Two weathered
Hickory nuts -
grey and
nibbled

Two ways to
get into a
Hickory nut

tiny
green
spider
on my
arm

Pine
bark

So glad I'd seen
one of these Eyed
Click Beetles
before he
buzzed
across
the pipe-
line and
bumped into
my leg!

Bright
yellow w/
rusty
spots

black with
random
white
specks

white rings around false
eyes

Cicadas in the trees · Indigo Buntings singing · Roika! Roika!

CAW! CAW! CAW! · Daisy watches intently · circles overhead, a black vulture

Two woodpeckers fly in to check out the trees behind me ·

Pussytoes & Cinquefoil
july 30

Fog and cool temperature made for a wonderful hike to the river. We headed downhill into a stiff, damp breeze that felt delicious after all the hot, dry weather we've had lately. Along the edge of the pipeline were long, flowering mounds of butterfly pea, the vines crawling over everything from hummocks of grass to fallen logs, all backed by swaying plumes of goldenrod. Yesterday's rain still puddled in the clay at the bottom of the hill near Meetinghouse Creek; here were the blooms of meadow beauty, Joe Pye weed, false dandelion, seed box, heal all, monkey flower, and sensitive brier.

Up we went, into the strip of piney woods between the pipeline and the hardwoods on the hill. The path here smelled fresh, with the essence of pine and damp earth thick in the air. Birdsongs came through loud and clear in the fog: a Carolina wren, an indigo bunting, and the jungle call of a pileated woodpecker. The dogs led me up to the rocky ridge and around to the river. The water was high and muddy, and rushing around Helen and Susan Islands. Mushrooms were everywhere, some tall and stately, others tiny and button-like, and many in-betweens. Fringed gentian bloomed along the edge of the low, mossy bluff beside the river, and Christmas ferns carpeted the rising slope behind us.

Heading home, I stopped along the trail to draw these pussytoes, cinquefoil, and various grasses that grew through a mat of cushion moss, while the dogs kept guard, wet from playing in the river.

July 30 · midday · overcast · windy and pleasant · Katydids chirruping in the trees · crows in the distance · The rattle of the white oak leaves reminds me of palm trees

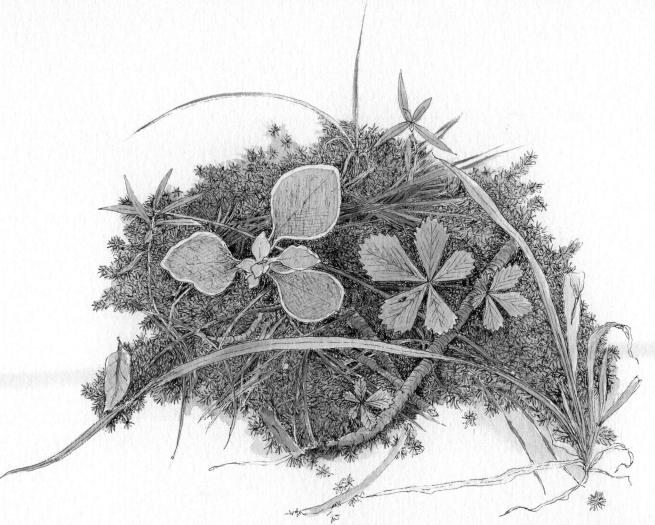

Woodland Sunflower, Butterfly Pea, Etc.

august 3

Our morning hike was delightful and cool and full of flowers. I found a new one today, pale spiked lobelia, tiny lavender-colored blooms on delicate stalks. I saw so many of them that it has probably been here quite a while, and yet it has somehow escaped my notice all these years. It must have a short bloom time.

The other flowers I drew today are regulars around Middlewood, old friends of mine. I know them well. The cranefly orchid is one of my favorites. The blooms arise on dainty brown stalks and have small purpley-green flowers that blend so well into the woodland floor that some years I miss seeing them. Each plant is made up of a tuberous root and one beautiful, dimpled leaf that unfurls in the fall and lasts all winter. The leaves are green and crinkly, with purple spots and vibrant purple undersides. The leaves are so bright in the winter woods that you can't miss them, but by early summer they are gone. In August, when the bloom stalk rises through the leaf litter, it is very difficult to see them, even when you know where particular plants are and you're looking for them. If you forget to look, forget it … unless you happen to have a seven-month old collie puppy who likes to snap at anything she walks past. She ate the top of one last week, took a bite of it as we walked down the path. I looked to see what she'd eaten and realized, *Oh, yes! It's that time of year … the cranefly orchids are in bloom.* Full bloom, actually. And I walk this path past a group of about ten plants every day and hadn't noticed them until today.

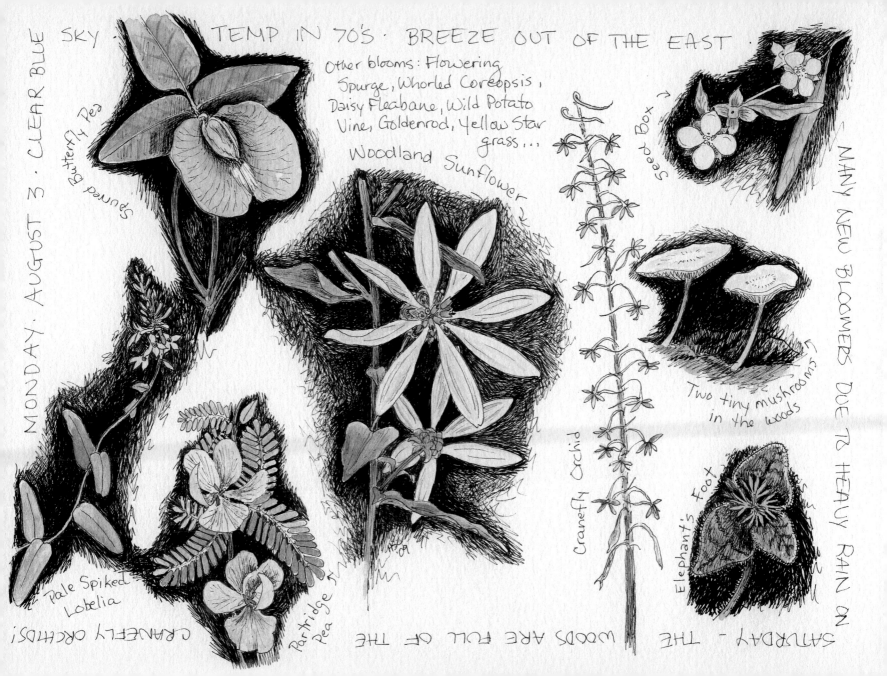

MONDAY · AUGUST 3 · CLEAR BLUE SKY · TEMP IN 70'S · BREEZE OUT OF THE EAST ·

Other blooms: Flowering
Spurge, Whorled Coreopsis,
Daisy Fleabane, Wild Potato
Vine, Goldenrod, Yellow Star
grass...

Woodland Sunflower

Spurred Butterfly Pea

Seed Box

MANY NEW BLOOMERS DUE TO HEAVY RAIN ON

Two tiny mushrooms in the woods

Cranefly Orchid

Pale Spiked Lobelia

Partridge Pea

Elephant's Foot

CRANEFLY ORCHIDS! WOODS ARE FULL OF THE SATURDAY - THE

Sassafras Fruit
august 6

As I slid down the steepest part of the trail, a rocky washout above Meetinghouse Creek, I came eye to eye with a small, fruiting sassafras tree. I've passed the tree many times this summer, but it wasn't until today that the red cups holding the tree's fruit finally caught my eye. They are a striking detail that I've never seen before. The greenish-purplish berries had a soft bloom, similar to grapes or blueberries. Being larger than the cups, they looked like miniature eggs perched atop miniature eggcups.

I used to think that fall brings out the best in sassafras trees, when the leaves turn vivid yellows, oranges, and reds. But last spring I noticed for the first time the fragrant yellow flowers. And now here are these beautiful little fruit, possibly all the more lovely because fruit production is sparse, as sassafras also reproduces through lateral root offshoots.

When I got home I looked up sassafras in several field guides and found some fun facts about it: 1) sassafras oil is used to flavor tobacco, root beer, and other beverages, soaps, perfumes, and gums, and 2) young leaves are ground into a fine powder to produce thick (mucilaginous) gumbo of Creole cooking. That doesn't sound very appetizing. I think I'd rather eat the fruit.

Thursday · August 6 · Sunny · warm · with a strong, cool breeze · in the treetops.

Bright red cups with greenish eggs →

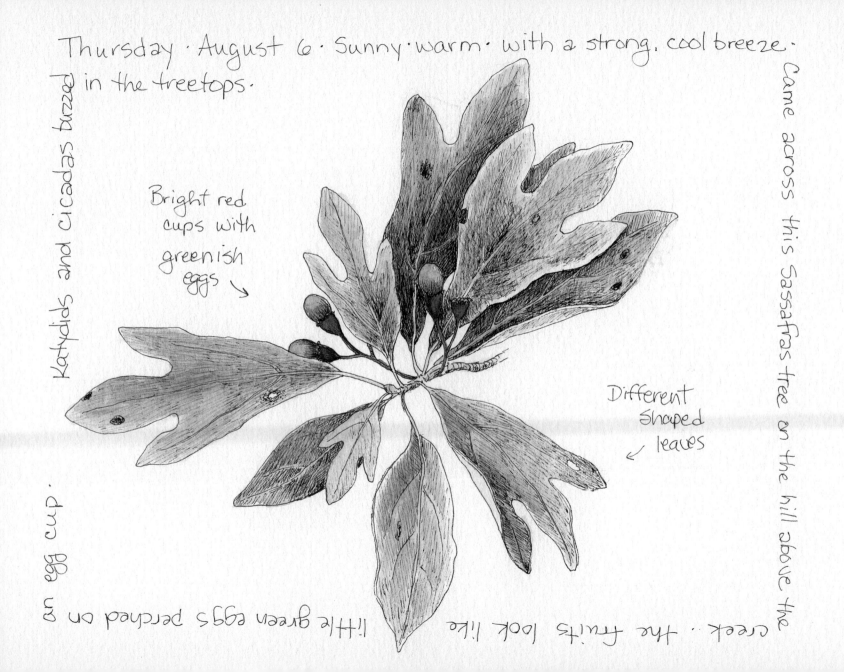

Different Shaped ↙ leaves

Katydids and cicadas buzzed

Came across this Sassafras tree on the hill above the creek · the fruits look like little green eggs perched on an egg cup ·

SHELF OR BRACKET FUNGUS
august 9

*T*hese shelf fungi, called dyers' polypore, are growing on the rotting stump of a tree we had to take down in the woods behind the house. Leaf litter surrounds the stump, and a single leaf sits on top. I leaned forward to brush this leaf away to get a better view of the fungus, except I couldn't. The shelves are growing around the oak leaf, incorporating the leaf into their structure.

Except for the white outer edges of the shelves, the leaf and fungus are the same shade as the rest of the woods, burnt umber. I've read that these polypores are a natural source for various colors of dye: green, yellow, gold, or brown, depending on the age of the fungi when it is used.

Other mushrooms and fungi are growing in the woods, but the mosquitoes and gnats are quite intense in the long, hot dog-days of summer, so it's hard to stay out long enough to draw them. Luckily, fall is on its way, with cooler weather and pest-free drawing sessions.

Hot!! Very hot! This shelf fungus found growing on the stump of an old tree. It is growing around the oak leaves that weigh next to nothing... I wonder why it doesn't push the leaf away instead.

Sunday, August 9.

Old stump →

Everything is the same shade of Burnt Umber

acorn cap

leaf litter

KUDZU, GOLDEN ASTER, & CAROLINA LOCUST
august 13

*K*udzu. Unfortunately we have our own personal patch of it at the top of our driveway. We try to kill it every spring by spraying with undiluted weed killer, but when we first moved here we saw copperheads occasionally slithering out of the kudzu and up to the road to soak up the sun. This is why we're not inclined to actually step into our kudzu patch. We only attack it from the edge, and therefore it will never, ever die.

A native of southern Japan, kudzu also grows in a few places along the edge of the pipeline, and in the heat of the summer the happy plants send long, tough vines across the path practically overnight. This morning, though, it seems to be at rest, tired even, as if it knows the growing season is almost over. This speckled leaf glowed under the overcast sky. I sat beside it, and as I drew in my journal a cool breeze riffled through my hair. Blue jays outnumbered other birds in the trees around me. *Jay! Jay! Jay!* Back and forth they called, as if they were having a conversation.

I began to hear clucks, cackles, and screeches that sounded like a rusty hinge. I looked behind me to see a huge flock of incoming birds silhouetted against the gray sky. They flew into the trees and field all around me, probably red-winged blackbirds, starlings, grackles, and cowbirds. These species often gather into flocks in the fall for safety during winter roosting. Today they flew in for about ten minutes, and then, with a loud, low *woosh,* they flew off to their next resting spot. Cicadas were also on the fly—one buzzed past my head. Perhaps the birds were snacking on fresh cicadas, nature's popcorn, in the trees.

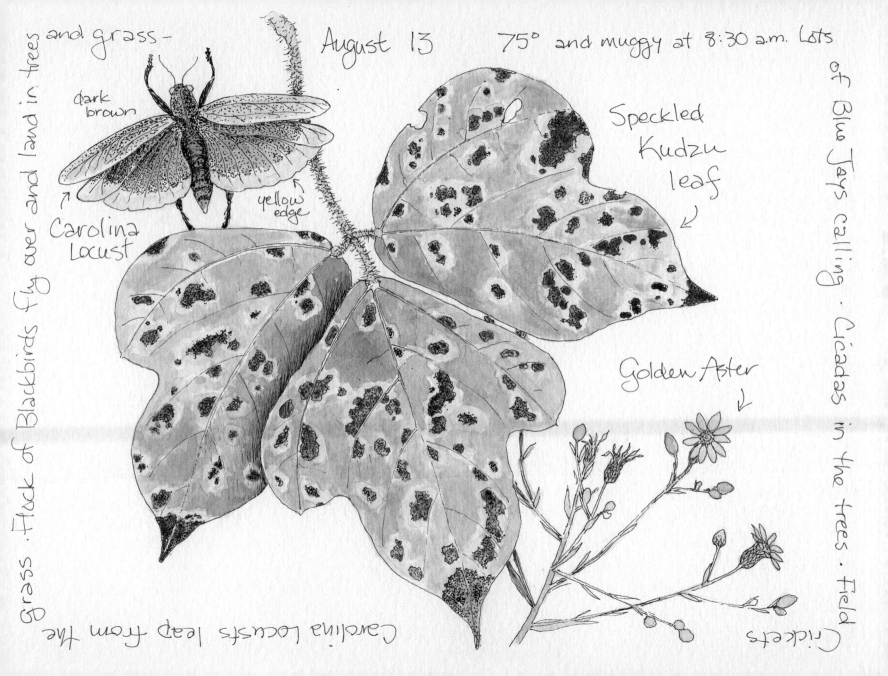

and grass— August 13 75° and muggy at 8:30 a.m. Lots

dark
brown

Carolina
Locust

yellow
edge

Speckled
Kudzu
leaf

Golden Aster

of Blue Jays calling · Cicadas in the trees · Field

Crickets

Carolina Locusts leap from the

Grass · Flock of Blackbirds fly over and land in trees

White Wood Aster
august 18

It was already 77 degrees and very humid when the dogs and I headed out at 9 a.m. High-pitched field crickets trilled, and cicadas buzzed in trees still dripping from the night's rain. Invisible spider webs were strung across the path. I managed to get some of the sticky strands across my face and in my hair. Even though I brushed and wiped and rubbed my face and shoulders, it didn't feel as if the webs were truly gone. I imagined a spider on my back, on my neck, in my hair. The only way to deal with this is to either 1) take your shirt off and check it for spiders, or 2) stop thinking about it, walk on, and focus on what's ahead.

Today I kept walking. Once out in the open field and its well-worn path, there were no more worries of spider webs. We hiked down to Meetinghouse Creek, up the hill and into the far woods, around the high rocky ridge that runs along the river. Daisy raced ahead as I looked for interesting rocks, mushrooms, or box turtles. I passed a nice patch of elephant's foot in full bloom in the filtered shade of high pines. At the river's edge I found these delicate white wood asters just beginning to bloom. There were itty-bitty white mushrooms all through the woods! The more I looked, the more I saw—up the hill, down the bank, thousands of tiny, bright mushrooms spread across the dark forest floor, like the Milky Way against the night sky.

August 18 · Clear skies · already hot & steamy (9:00 am.) Hiked with Kaye.

White Wood Aster
growing beside Lawson's fork:

older plant has nibbled leaves &
varied leaf bases – newer plant has
mostly heart-shaped leaf bases

Patches of tiny white mushrooms
all along the riverbank
and in the woods

these growing on a fallen twig.

deeply serrated
margins

Smooth
margins
on
smaller
leaves

Heart-shaped
leaf base

nibbled

zig-zaggy stem at
bottom is purplish

Box turtle · Five-lined skink with neon-blue tail

Olive & Daisy to the river · Two different buzzes from the

trees. high (crickets?) & low (cicadas?)

· Tiny mushrooms ·

St. Andrew's Cross, Pencil Flower, & Bitterweed
august 24

I can tell summer is losing its grip. It's interesting to note that I understand more every year that the seasons, which I used to consider fairly distinct, are really quite blurred. Cat brier and Virginia creeper leaves begin turning red as early as July; fuzzy spring-like oak leaves sprout until frost. During this morning's ramble I saw the first "fall" silvery aster bloom for the year, and grass-leaved and golden asters, which have been blooming for a couple weeks. Thoroughworts (upland, round-leaved, and hyssop-leaved) are in bloom, but fading. Tall goldenrods already brighten the woodland edges. Joe Pye weed and pale indian plantain are in full bloom down by Meetinghouse Creek.

While I drew, fall field crickets trilled in the field behind me, and a white breasted nuthatch's loud and nasal *ank ank! ank ank! ank ank!* gave away his position as he walked head-first down the trunk of an oak looking for insects. I remember the bird's name and differentiate him from the brown creeper, who also hops on tree trunks, by thinking what a "nut" the nuthatch is to hop head-first straight down the tree. The way the brown creeper does it, starting at the bottom of the tree and spiraling up the trunk, seems so much easier. The name nuthatch actually comes from the bird's habit of wedging nuts into cracks in a tree bark, then whacking at it with his sharp bill to "hatch" the nut from its shell.

A pileated woodpecker screamed several times close by. A breeze kicked up and stirred the leaves, eventually becoming a steady cooling wind that persuaded me to stay a while after journaling, just to enjoy it.

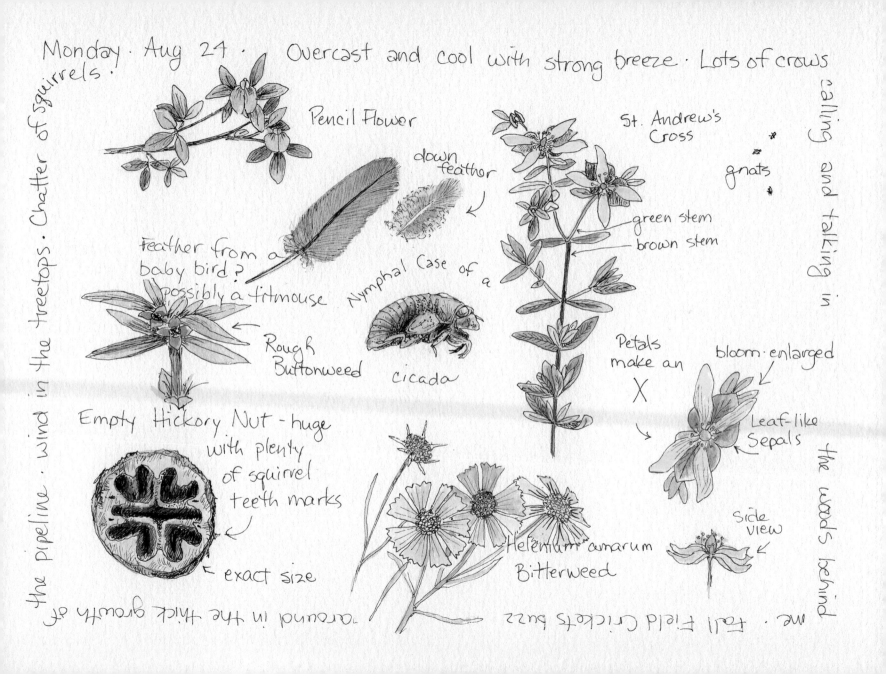

Monday · Aug 24 · Overcast and cool with strong breeze · Lots of crows

Pencil Flower

St. Andrew's Cross

gnats

down feather

green stem

brown stem

Feather from a baby bird? possibly a titmouse

Rough Buttonweed

Nymphal Case of a

cicada

Petals make an X

bloom · enlarged

Leaf-like Sepals

Empty Hickory Nut - huge with plenty of squirrel teeth marks

side view

exact size

Helenium amarum Bitterweed

calling and talking in the woods behind

the pipeline · wind in the treetops · Chatter of squirrels ·

me · Fall Field Crickets buzz · around in the thick growth of

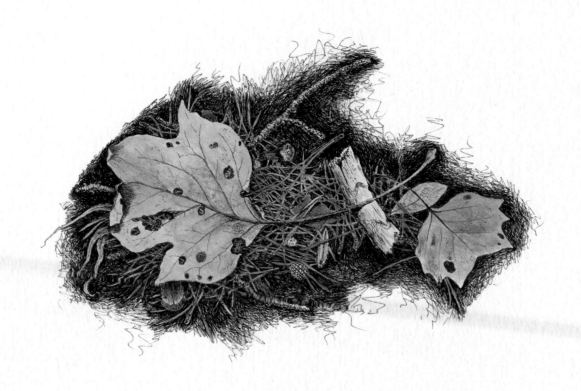

Fall

YELLOW LEAVES ON A WINDY DAY

september 1

We hiked east on the pipeline into a strong breeze. When we left the open field and followed the path through the woods, trees blocked the wind, but I heard it roar and saw it in swirling treetops. Yellow leaves tore from branches and twirled through the air, onto the path. I stopped to pick up leaves and noticed the huge tulip poplar they had come from. It was green, but yellow leaves dotted the crown as if the tree had been decorated by hand. Under the tree lay a carpet of yellow leaves fallen on windless days. They lay in a tidy circle, like a Christmas tree skirt.

I settled down to draw, but from behind me came the squawks of crows starting such a ruckus I had to go see what was going on. As I approached, the scream of a red-shouldered hawk echoed from the crow-crowded spot. Over and over he shrieked, while the crows screeched and cawed and flew in and out of the thick canopy of a large loblolly pine. The crows saw me as I crept closer, then squawked and flew. After a moment of silence, the huge hawk flew out from the pine, still screaming, and landed on a bare oak branch very close to me. *Why are you still screeching?* I wondered. *The crows are gone now.* Two minutes later he flew screaming back into the pine. Immediately, out of the pine flew an enormous, dark, and silent great horned owl. The noisy hawk chased him into the treetops.

On the way home I came upon an antler wedged in a small tree at the height where a young buck might have rubbed and lost it last winter.

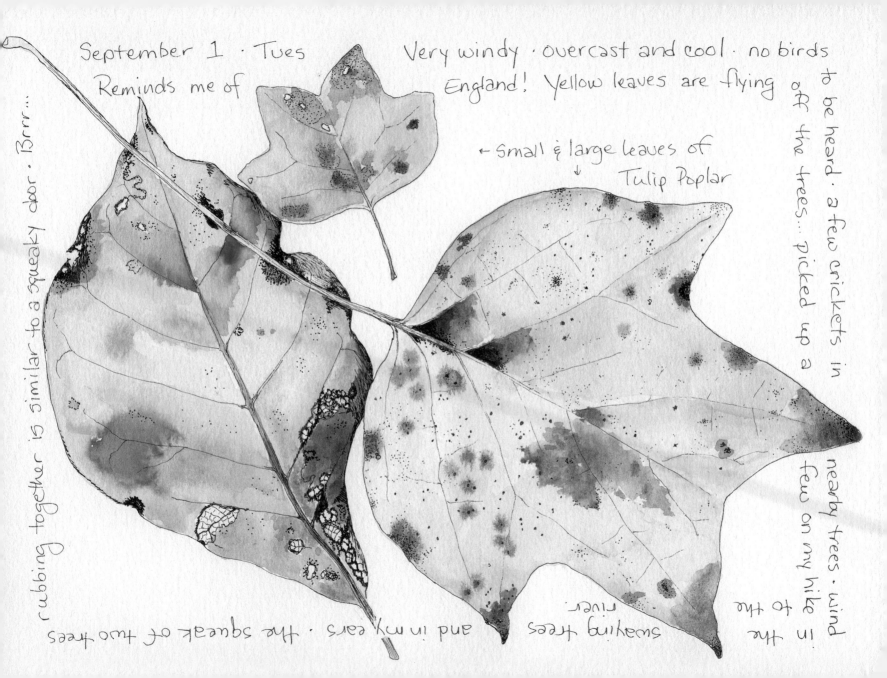

September 1 · Tues Very windy · overcast and cool · no birds
Reminds me of England! Yellow leaves are flying

← Small & large leaves of
 ↓
 Tulip Poplar

to be heard · a few crickets in
off the trees... picked up a
nearby trees · wind
few on my hike
in the

rubbing together is similar to a squeaky door · Brrr...

the squeak of two trees and in my ears swaying trees out to the
 river.

Whorled Coreopsis, Aster, & Goldenrod
september 11

We headed out in the cool of the morning, when dew still lay heavy on the grass and dark shadows of pines, maples, sourwoods, and oaks stretched all the way across the pipeline field.

At the crest of the hill I knelt to inspect a four-inch puffball. The dogs dashed ahead of me, which is good. It means I can keep an eye on them. When Duke is playing he is clueless to his surroundings, and recently he knocked my legs out from under me while I was watching two tiger swallowtails on a Joe Pye weed. He slammed into me like a baseball runner sliding into first base. Now I like the dogs to run where I can see them.

It was noisy out this morning. Crickets buzzed in the field, cicadas' staccato clicks echoed from the trees, red-bellied woodpeckers chirred in the woods as they talked to their mates and ate insects from dead branches. A Carolina wren's insistent warning trill echoed from the woods nearby. I think the dogs were threatening the birds' calm morning. Their distress calls reminded me of the day I walked out of my studio and sat on the top step of the porch without realizing that a mama wren was teaching her babies to fly right there. She landed on the oak trunk five feet away and fussed and fussed. *What's wrong*, I wondered. It took me a few minutes to see two baby wrens taking short test-flights from limb to limb, and to realize, *Oh—it's me!* This morning's alarm call was exactly the same.

I settled on the far hill to draw a coreopsis and study its petal patterns, where inside I found a tiny white crab spider in a yellow center, hiding from the world outside.

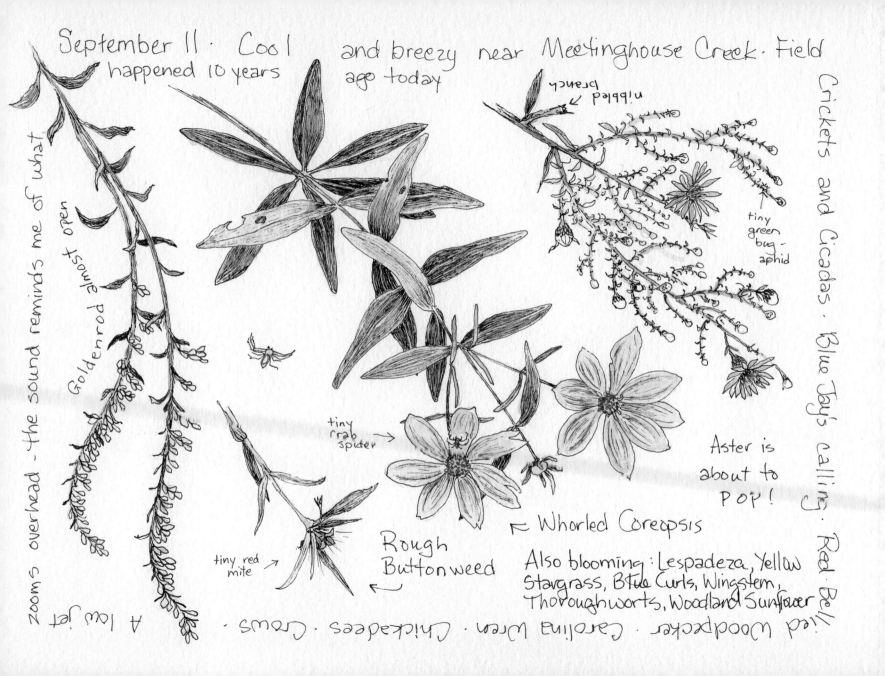

September 11 · Cool and breezy near Meetinghouse Creek. Field

happened 10 years ago today

nibbled branch

tiny green bug- aphid

Goldenrod almost open

zooms overhead - the sound reminds me of what

A low jet

tiny crab spider

tiny red mite

Rough Buttonweed

Whorled Coreopsis

Aster is about to POP!

Also blooming: Lespadeza, Yellow Stargrass, Blue Curls, Wingstem, Thoroughworts, Woodland Sunflower

Crickets and Cicadas · Blue Jays calling · Red Bellied Woodpecker · Carolina Wren · Chickadees · Crows ·

Red Leaf & Helenium
september 16

*T*ook an early walk today and enjoyed the long morning shadows and wind in my hair. Tuesday's muffled silence had disappeared, and instead I heard traffic from Pine Street two miles away, a distant neighbor's lawn mower, a dog barking across the river, as well as the dog's owner yelling, "*Shut up!*" It's amazing how noisy some days are out here in the woods.

Along the way I found half of a small white bird egg, a tiny puffball that poofed its brown spores when I poked it, and the seedpods of a sensitive brier. I picked one of the brier seedpods to draw and got a handful of invisible splinters. Ouch! For the record, the splinters are so slight you can't see to pull them out, but they still hurt. I dropped the seedpod, and while attempting to pick prickles from my hand, I noticed on the ground a beautiful, crimson leaf from a small black tupelo tree along the pipeline. It's a leaf that has confused me for some time, until I finally found a photo of the variable growth that happens around here: leaves with a few large teeth instead of the typical smooth margins. Black tupelos are one of the first trees to turn red in the fall, and this one was definitely the first of the year for me. As I admired the leaf it occurred to me that this was a much safer thing to draw than the seedpod, and I thought the red contrasted nicely with the yellow of the nearby sneezeweed, also known as Helenium. A tiger moth fluttered up and landed briefly, its brown and cream patterned wings and orange under-wings bright against the red clay.

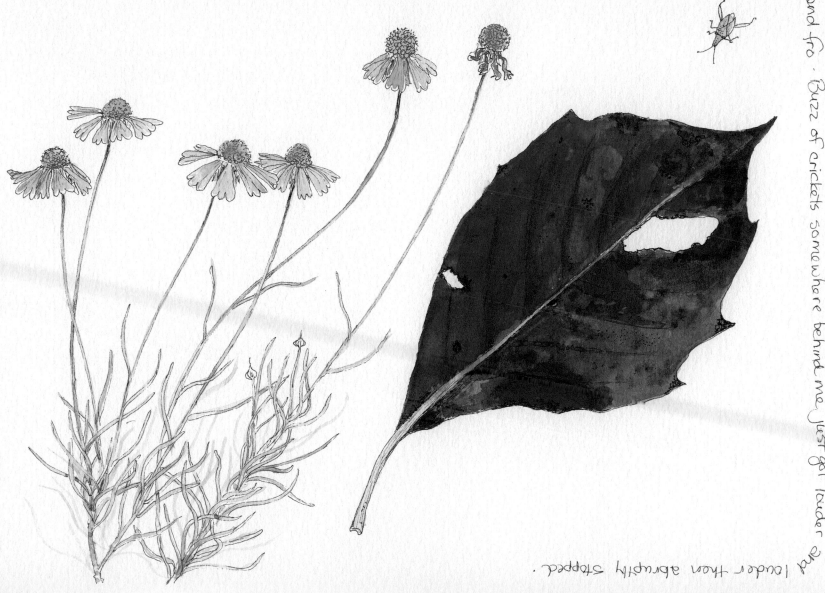

September 16 · Cool and windy · Chickadees in the pines · tall red grass plumes waving to and fro · Buzz of crickets somewhere behind me just got louder and louder then abruptly stopped.

FALL TANGLE
september 27

The day shone brightly, with early autumn sunrays striking the beginnings of many fall blooms: yellow stargrass, goldenrod, blue curls, gerardia, lobelia, as well as goldenaster, New York asters, thoroughworts, and heath asters, which are just opening their pale stars. Large puffballs had popped up on a portion of the pipeline; deer had nibbled some. We came upon a box turtle, but before I knew it our neighbors' hound pounced on it and the turtle disappeared into his shell. A pileated woodpecker called his *kuk! kuk!* as he flew from tree to tree to let his mate know where he was.

Along the way I noticed this tulip poplar leaf sitting atop a tangle of asters and grass leaves. I stopped to study it and discovered that beneath the poplar leaf was a red oak leaf, and on the oak leaf sat a Carolina locust. Aster branches poked through holes in both leaves. So, which came first? Did the leaves fall onto the aster in just the right way to allow the stems to poke through the hole? Or did the aster grow up through the holes?

As I considered what would happen if I tried to sit and draw, the dogs noticed that I'd stopped walking, so I did my best "walk-two-steps-forward" to fake them out. *See, I'm still walking!* Sure enough, they turned and ran on. I took my journal out and drew standing up, which is neither meditative nor peaceful, but still fun. The intricacies of the tangle fascinated me. It was a puzzle to draw—grass over aster branch, under that branch, disappears beneath leaf, only to come out down there …. And so, I'm not sure which came first. Of course, it doesn't matter one bit.

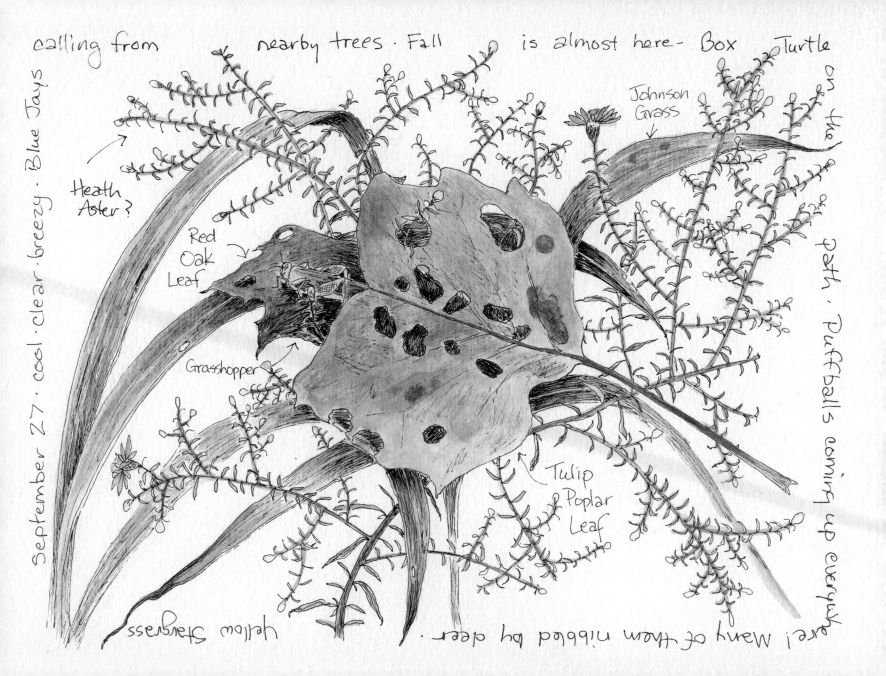

calling from nearby trees. Fall is almost here- Box Turtle

September 27 · cool · clear · breezy · Blue Jays

Heath
Aster?

Red
Oak
Leaf

Grasshopper

Johnson
Grass

Tulip
Poplar
Leaf

on the path · Puffballs coming up everywhere! Many of them nibbled by deer.

Yellow Stargrass

Resurrection Fern
september 28

A front came through last night, so today is all blue skies, dry air, and wind twirling the treetops. The dogs and I set out around 11 a.m. to hike to the rocks in the woods at the far end of the lower pipeline. My family refers to this ridge as "The Lion King Rocks" because of the way they jut out at an angle from the top of the hill—a smaller version of the big rock in one of my boys' favorite childhood movies.

In the woods near the rocks I almost stepped on a five-inch long eastern box turtle that was crossing the path. The dogs leapt right over it and continued on, so I sat to draw him. It wasn't long before the dogs came running back to investigate why I had stopped. Sniff-sniff-sniff, paw, paw, and Daisy's questioning growl, asking, *what are you*? I felt very sorry for the turtle, so I got up, moved on, and let him have his peace.

We arrived at the big rocks to find the resurrection fern, one of the polypody ferns that grow on this ridge, lush and completely unfurled due to last night's rain. Resurrection fern grows on ledges of granite boulders where old leaves accumulate and break down into humus. In other places I've found it growing on tree trunks and branches. It's a small fern whose leaves are leathery and evergreen when there is enough water. During dry spells the leaves turn brown, roll up, and look quite dead.

While I drew, a stronger wind blew in and twirled the treetops. *Crack, thud!* told me where branches were snapping and falling in the wind, but through it all I could hear a red-bellied woodpecker as he chirred and pecked in a nearby tree.

September 28 · Clear skies · Windy and coolish · low 70's · Sitting
- end rains · Chickadees

Resurrection Fern

Leaf litter on ledge

actual size of frond →

Growth habit of
Resurrection Fern.
On shaded granite
boulders - on a ledge where
leaves have fallen and decayed -
Moss and Lichens

Box Turtle
walking past...
Radu and
Daisy
oblivious!

Tiny red
spider walks across
the page...

Resurrection Fern is full and green after the week

on the "LiON KiNG" rocks - the ridge high above Lawsons

Fork · Crows · red bellied woodpecker · dogs panting · wind in the treetops

Hickory Leaf, Aster, & Gerardia
october 13

What a beautiful, sunny day! Yesterday's soaking rains have moved on, leaving us with deep blue skies surrounding a waning crescent daytime moon. While we were out this morning we walked under a huge flock of blackbirds, grackles, and starlings. They squeaked, squawked, and chattered so loudly they didn't hear us crunch into the woods to look in the trees. No surprise since I could hardly hear the leaf-crunch myself. There were hundreds, maybe over a thousand of them, and I have to admit that I was reminded briefly of Hitchcock's movie *The Birds*, but I walked all around under them and closed my eyes to better appreciate the wild, rusty-hinge calls of the grackles. We settled on the pipeline near them so that I could enjoy the aviary feeling of being so close to their noises and activity.

After about five minutes the birds suddenly went silent, then they all took off with a loud, collective *WHOOSH!* They flew out in formation and over the pipeline, veering and rolling in the blue October sky like a school of fish in the sea. I was awed by the unexpected up-close view of their flight. They whirled and wheeled above me for a few minutes before they disappeared. In the silence that followed I started hearing the woodland birds again. I closed my eyes, lifted my face to the sun, and heard birdsong: chickadees, titmice, red-bellied woodpeckers, as well as blue jays and American crows cawing in the distance.

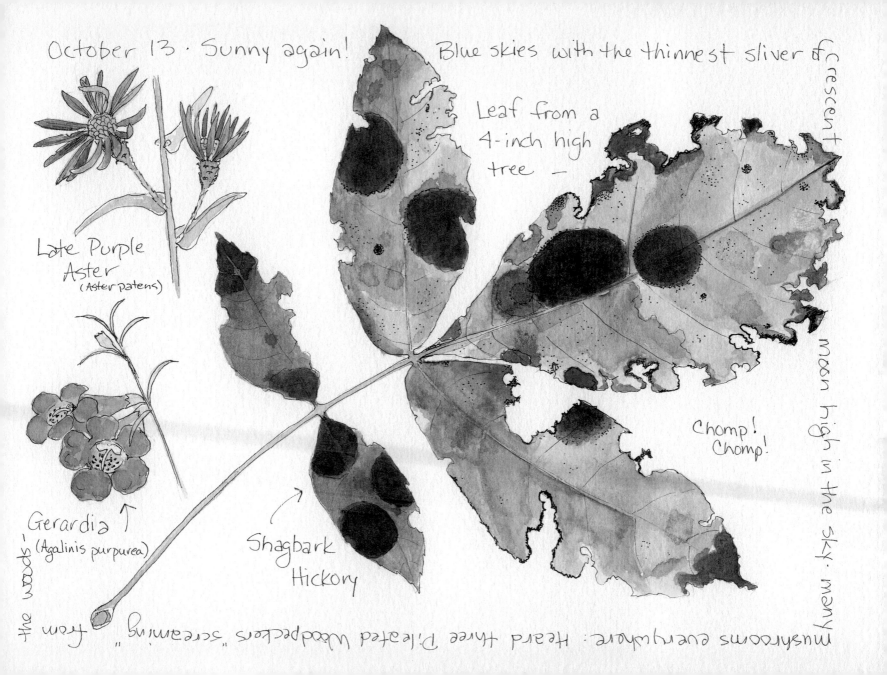

October 13 · Sunny again! Blue skies with the thinnest sliver of Crescent

Late Purple
Aster
(Aster patens)

Gerardia ↑
(Agalinis purpurea)

the woods —

Leaf from a
4-inch high
tree —

Shagbark
Hickory

Chomp!
Chomp!

moon high in the sky. many mushrooms everywhere: Heard three Pileated Woodpeckers "screaming," from

SOURWOOD & ASTER
october 16

Early fall in the Piedmont is when our many sourwoods begin turning pink. The fields are still full of September's colorful display: the yellows of sweet goldenrod and wooly golden-aster, the blues of calico and silvery asters, the violet of late purple asters, the soft pink of slender gerardia.

The dogs and I hiked on the pipeline in the cool shadows of the morning. I noticed two piles of fresh fox scat, typically full of persimmon seeds, in the cut-through between the three pipelines. On the lower pipeline I heard harsh cries of distressed crows in the direction of the rocky ridge. For curiosity's sake, I picked up my pace. Twice, as I hurried toward the ruckus, the fretful cawing stopped for about ten seconds so that I thought I'd missed the event, only to begin again just as loud and persistent. It was a hawk or owl in the crows' territory, and I wanted to see which.

I don't know if it was my approach or the crows' mobbing that finally encouraged the hawk to leave, but when I got thirty feet from the cedar at the center of the commotion, I heard the deep *whoosh-whoosh-whoosh* of large wings and saw the flash of a red-tailed hawk's ruddy tail as he flew off, escorted by eight of the squawking crows. Once they were gone, silence fell over the woods.

I wandered on looking for rocks and feathers, and within five minutes the other little birds started singing again. Back on the pipeline I settled under a twisty-trunked sourwood to draw in my journal. The dogs explored the woods and chased a deer, returning to me panting hard, with muddy paws and speckled with green beggar's ticks.

CAW! CAW! CAW! CAW !!

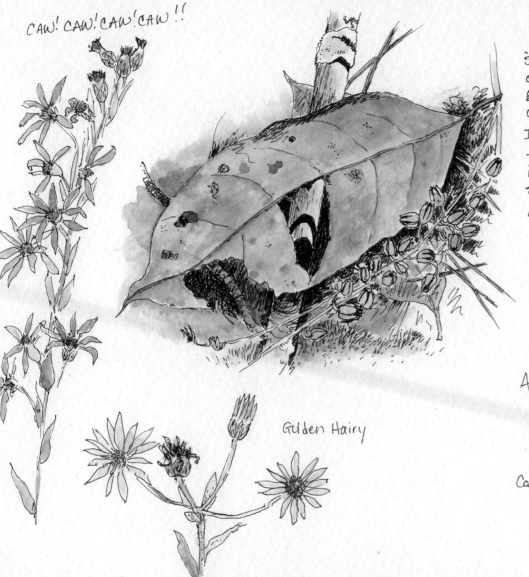

Sitting under
a Sourwood - a
bird-shadow just
crossed the page.
Interesting shadow
from sun sneaking
inbetween leaf and
stick.
Moss & old pine needles

Acorns dropping
in woods behind
me.

Asters blooming AWAY !

Golden Hairy

Calico

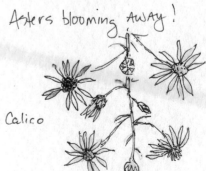

Crickets' high trill in the woods all around. Blue Jays !

October 16, 2008 Late morning on the pipeline.

Sunny & warm. Crows in the distance. Red-bellied woodpecker in a nearby tree.

WILDLIFE TRACKS
october 20

*T*oday was still pretty cool for mid-October, so the afternoon sun felt good on my back as we headed east. We'd reached the far end of our usual path when I noticed some amazingly clear tracks in the damp sand, the shadows sharp due to the low sun. The first I noticed were from a red fox. As I admired the fox tracks I saw that a wild turkey had also walked this way. The track I drew even showed the rough texture of the bottom of the turkey's foot.

In the same area were deer tracks. It's interesting to note the size of the tracks and to picture the animal in your mind. Often I'll find deep, wide splayed tracks that show the dewclaws, made by a running and leaping buck. The print I found today had small dots for the dewclaws pretty far back, so I think this is a doe's back footprint. The smaller, sharper print is from her fawn.

Upon closer inspection I realized that some of the prints I thought were fox (four toes) were something else (five toes). I drew them carefully and, once home, looked in my animal tracks field guide to identify them. I think the five-toed animal track is that of a skunk.

The other obvious track in that stretch of damp was a really big one, quite clear and deep. Oh, yeah. I happened to have some good track-makers with me, at the moment patiently watching and waiting for me to finish up and head home. I'd say this big track belongs to one of them.

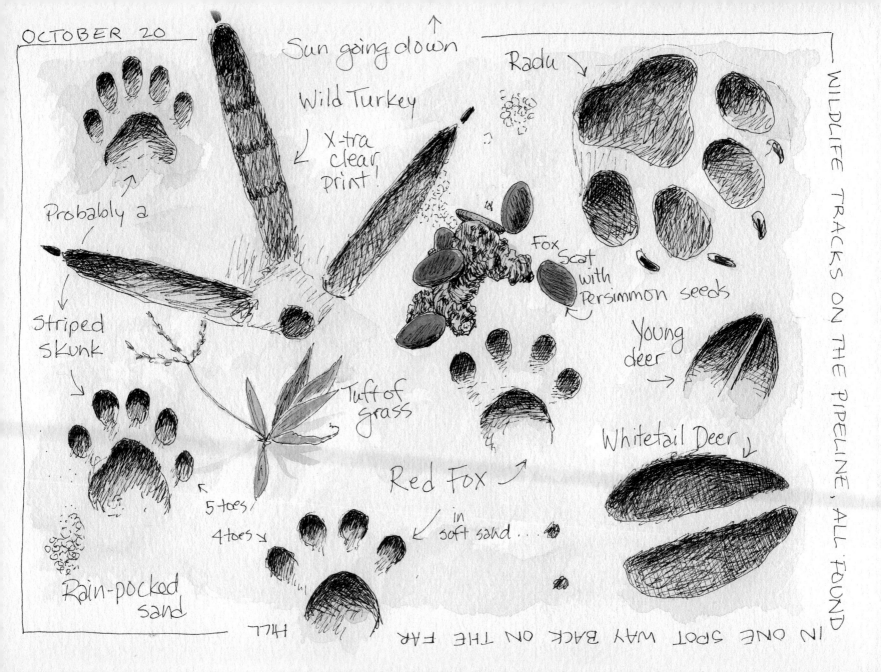

OCTOBER 20

Sun going down

Wild Turkey

X-tra clear Print!

Radu

Fox Scat with Persimmon seeds

Probably a

Striped Skunk

Tuft of grass

Young deer

Red Fox

Whitetail Deer

5 toes

4 toes

in soft sand...

Rain-pocked sand

MAPLE LEAVES, SEED BUG, & COMMON SULPHUR
october 26

*T*oday was warm, damp, and cloudy, which made the woods vibrate with color, especially in the maple, cherry, sourwood, and sassafras trees, as well as the Virginia creeper vines and the winged sumacs. The dogs and I hiked toward the far fence and stopped along the way to settle at the top of the hill. I was looking around for something to draw when a gust of wind whooshed through. It stripped leaves from the maples behind me and twirled them in the air like confetti. Some leaves danced and whirled in spirals like helicopter blades, some sashayed back and forth as if they were post-it notes dropped from a small plane. Others swung wildly and looped back up in an acrobatic twist, flying even higher into the air. They all eventually landed around me with a soft click, some on my page. How could I not draw them?

While I worked, field crickets trilled from the brown October grass, and a red-bellied woodpecker chirred from a pine he busily worked, looking for bugs. Daisy became interested in digging a hole right beside me. *Scratch, scratch, scratch.* Pause. Shift. *Scratch, scratch, scratch, scratch.* Pause. Shift. The clay soil, damp from yesterday's rain, gave way easily to her claws. *Scratch, scratch, scratch.* Pause. Shift. A bug landed on my knee, and I quickly sketched it. At home I looked it up and found that it was a long-necked seed bug.

On the way back, a question mark butterfly fluttered down the trail towards us and landed on my arm. What a sight! The vivid blue edging of its wings shimmered against my blue sweater. Daisy and I admired it for a moment until it flew. Daisy gave it a half-hearted chase, then turned to race me home … a race she always wins!

occasional spitting rain · field crickets' trills and chips come from

Common
Sulphur

Long-necked
seed bug →
landed on
my knee

Maple leaves blown from
the trees behind me

Red & yellow maple leaves fly like confetti when a gust of wind blows·

October Shadows
october 29

Cold again today, and still windy. We walked to the top of Kudzu Hill, the hill that has a panoramic view of the rolling hills of the South Carolina piedmont and the mountains of North Carolina. While walking I passed through eddies of warm air swirling within the colder air, and in those warm pockets were butterflies: buckeyes, folded-wing skippers, and a tiny checkerspot. I am fascinated by the idea that the butterflies can stay within the moving pocket of warmth. Carolina locusts didn't seem to need the warm pockets—they were everywhere!

As we walked through the pale Johnson grass seedheads on the windy hill, locusts exploded in front of me, flinging themselves away on yellow and brown wings. *Bzzzzzzzzt!* In the clear, blue distance were all the mountains and ranges we are ever able to see: Hogback Mountain and Melrose Mountain, White Oak Mountain and Tryon Peak with its radio towers, are the closest and the deepest smoky blue in color. To the right of that are the mountains around Lake Lure and Bat Cave, and, farther, the Great Craggy Mountains and the massive Black Mountains, the range that includes Mount Mitchell. All around me wind blew through the pale grass and sent red maple leaves dancing from their trees. A lone tulip poplar cast a long, cool shadow between the mountains and me.

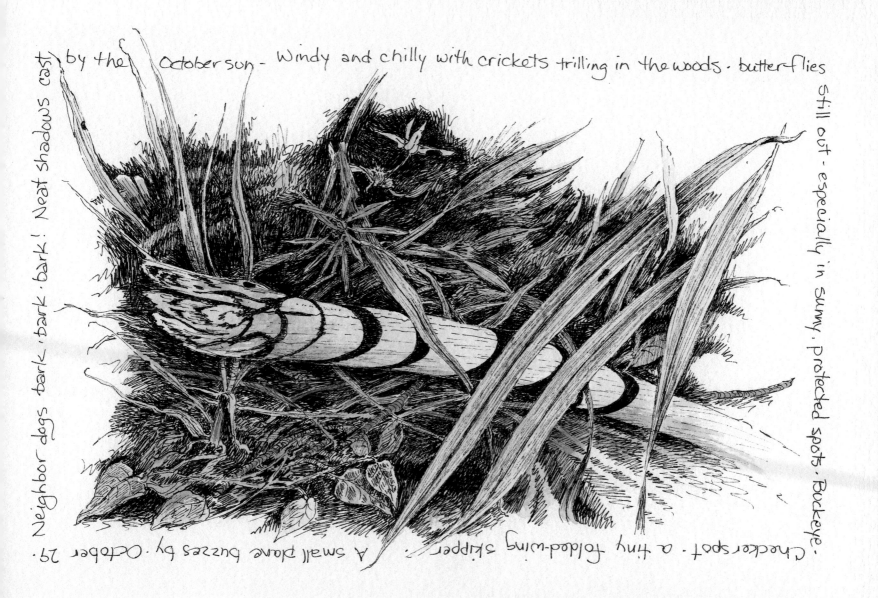

by the October sun. Windy and chilly with crickets trilling in the woods. butterflies

still out. especially in sunny, protected spots. Buckeye.

Checkerspot. a tiny folded-wing skipper.

A small plane buzzes by. October 29.

Neighbor dogs bark. bark. bark! Neat shadows cast

CRANEFLY ORCHID, SPOTTED WINTERGREEN, & WOODLAND SEDGE
november 1

When we headed out today I was surprised that the weather was not at all what the computer had indicated. On the map it had looked like it would be sunny, but instead it was cloudy, damp, even misty at times. The wind and the chill went straight to the bone. The dogs waited while I ran back in to grab a jacket, then off we went. When we reached the top of the hill I could indeed see blue skies and sun way out on the western horizon. The sun never made it to Middlewood, though, and the misty fog is still here as I type at 4:30 p.m.

The dogs and I wandered down the pipeline until about halfway to Meetinghouse Creek, when we turned right and climbed a bit of steep, north-facing hill. I placed my sit-upon under a canopy of thinning bright red and mustard yellow leaves that shivered in the wind. As I settled in I noticed there were evergreen plants all around me: Carolina jessamine, woodland sedge, spotted wintergreen, American holly, cushion moss, and the lovely, purple-backed leaf of the cranefly orchid. Crows cawed, and their wings flapped loudly as they passed overhead. The dogs panted as a result of an earlier deer-harassment run, and leaves clicked as they landed on the leafy woodland floor.

My fleece jacket and the scarf around my neck helped me stay warm on the hill for an hour or so. As soon as the bone-chill set in, I packed up my stuff and headed on back. The dogs ran ahead and led me through the colorful woods to home and the mug of hot chocolate that I'd been craving.

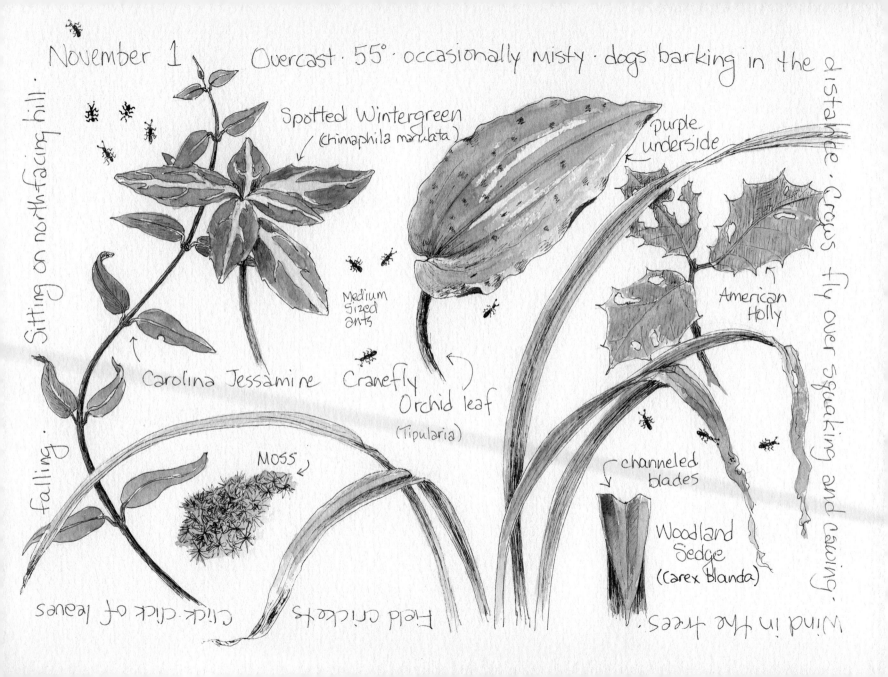

November 1 · Overcast · 55° · occasionally misty · dogs barking in the distance · Crows fly over squawking and cawing · Wind in the trees.

Sitting on north facing hill.

Spotted Wintergreen
(Chimaphila maculata)

purple underside

American Holly

Carolina Jessamine

Medium sized ants

Cranefly
Orchid leaf
(Tipularia)

Moss

channeled blades

Woodland Sedge
(Carex blanda)

falling.

Crick·click of leaves · Field crickets · Wind in the trees.

SHADES OF BROWN
november 3

*I*t was very late afternoon when I finally got to take the dogs out for their daily walk. We wandered around Kudzu Hill and checked on some weird things I've been keeping an eye on for a couple of weeks. I first thought they were mushrooms, but now I see they are stalked puffballs. The first time I saw them, their tops had big "cracks" that looked like dark brown lightning bolt shapes in the buff-colored mushroom top. Each time I've checked on them the cracks have gotten deeper, wider, and darker. Today they were completely covered with light-brown spores, the cracks no longer visible. I tapped one with a stick—*tap tap tap*—and it sounded hollow. A fine puff of spores floated above the ball. I considered drawing one, but on second thought chose to tackle it later … maybe next week. Today I decided to sit out in the fading evening light and draw some of the frost-bitten wildflowers and grass on the pipeline.

By the time I headed home the day was at an end. From the pipeline the sky still remembered the sun and was bright in the west, while night was a dark blue smudge on the eastern horizon. A waxing gibbous moon hung silent in the dusky blue sky just above the trees. Down towards Meetinghouse Creek a barred owl began hooting on the far hill. When I stopped to listen I realized it was not one but three owls calling back and forth, asking, *Who cooks for you? Who cooks for you-alllllll?* The trilling song of fall field crickets in the grass faded as we headed through the trees to home.

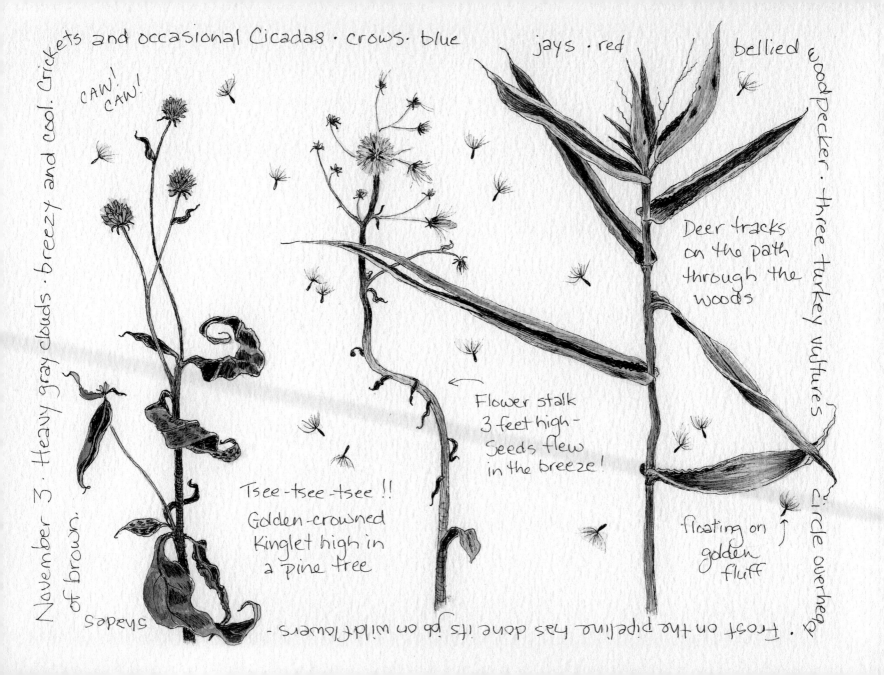

November 3 · Heavy gray clouds · breezy and cool. Crickets and occasional Cicadas · crows. blue jays · red bellied woodpecker · three turkey vultures circle overhead · Frost on the pipeline has done its job on wildflowers - shades of brown.

CAW! CAW!

Deer tracks on the path through the woods

Tsee-tsee-tsee !! Golden-crowned Kinglet high in a pine tree

Flower stalk 3 feet high - Seeds flew in the breeze!

floating on golden fluff

LATE BLOOMERS
november 11

Leaves were falling fast today, criss-crossing in midair like a heavy snowfall. The air was crisp and the sky cobalt blue as I hiked with the dogs to the rocky ridge. On the way I collected wildflower seeds for a friend's birthday: golden hairy aster, silvery aster, gerardia, goldenrod, and whorled-leaf coreopsis, so that she can begin her project of turning an old pasture into a prairie.

We crossed the fence line into a place where long ago huge boulders, probably once perched like our Lion King Rock, rolled down from the ridge into the mountain laurel thickets that line Lawson's Fork. There were many small evergreen plants growing on the steep, north-facing hillside forest: dwarf heartleaf, cranefly orchid, spotted wintergreen, Christmas fern, along with the last remaining pale-pink maple leaf viburnums and many cushions of moss. Amid the brown leaf-litter I also found a plant unknown to me. It had two five-inch leaves, each with three distinctive lobes. Quite unusual. Back at home I think I found the plant in one of my field guides. The new plant's leaves look to be goldthread, which blooms in May-July in mossy woods. The lustrous leaves and delicate flowers arise from slender, leafless stalks. I'll have to come back when they bloom to see if the flowers match my field guide. The only way to be sure today would be to dig one up for a look at the roots, which should be gold, thread-like underground stems.

I began to get cold down in the shade, so the dogs and I climbed up the hill and retraced our steps to the pipeline. I settled in the sun to draw these beautiful late blooming wildflowers.

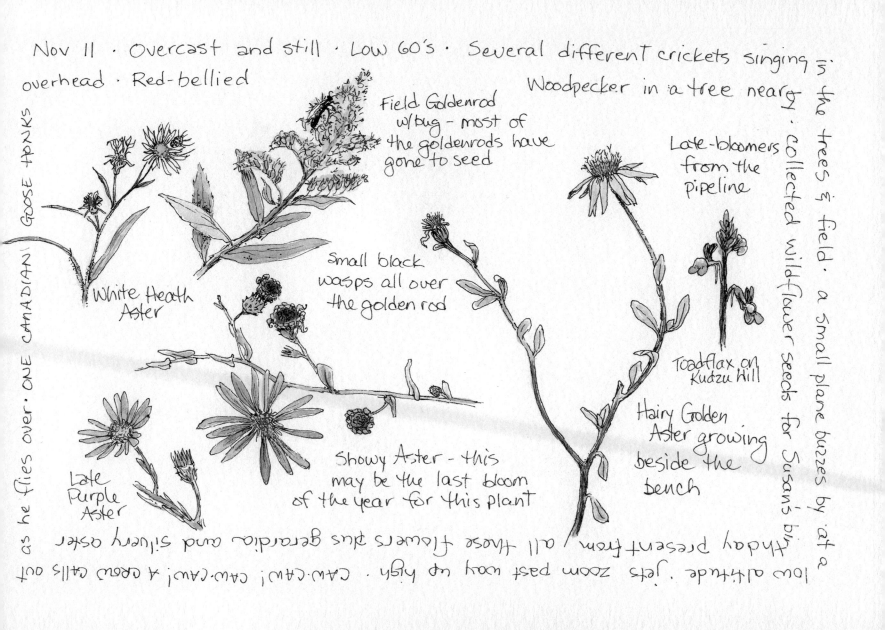

Nov 11 · Overcast and still · Low 60's · Several different crickets singing overhead · Red-bellied Woodpecker in a tree nearby · Collected wildflower seeds for Susan's birthday present from all these flowers plus gerardia and silvery aster · Jets zoom past way up high · CAW·CAW! CAW·CAW! A crow calls out as he flies over · ONE CANADIAN! Goose honks in the trees & field · A small plane buzzes by at a low altitude.

Field Goldenrod w/bug – most of the goldenrods have gone to seed

Late-bloomers from the Pipeline

White Heath Aster

Small black wasps all over the golden rod

Toadflax on Kudzu hill

Late Purple Aster

Showy Aster – this may be the last bloom of the year for this plant

Hairy Golden Aster growing beside the bench

ROCKS!
november 15

*T*oday was beautiful, with temperatures in the 70s, skies of cobalt blue, and sprays of colorful leaves still remaining on maples, dogwoods, hickories, and sourwoods. I headed up the pipeline and turned right into the woods to visit my favorite old sourwood and see how it was doing. It's a treat to come to know a place well enough to have special trees, shrubs, or flowers to visit throughout the year. And in some instances it can be a special place that has all the above. The fallen leaves underfoot rattled and crunched as I hiked a short way through the woods. Fall field crickets trilled from the pipeline, and from somewhere nearby came the steady, hollow *knock knock knock* of a pileated woodpecker.

My favorite old sourwood had only a spattering of pinkish-red leaves still dangling from the branches; the rest had fallen and turned into a lush carpet under the tree. It's a huge, twisting old tree, with a summer canopy so thick that nothing else grows under or around it. Large branches that have fallen look like serpents wiggling through the sea of leaves.

After visiting with the tree for a while I went down to the creek to sit in the sun and enjoy the breeze. I squatted like the kid I still am inside and found some interesting rocks to draw: various combinations of quartz, feldspar, hornblend schist, and silver muscovite mica. A buckeye butterfly flitted around over the field, and Daisy came and sat beside me, closed her eyes, and put her long face into the gentle breeze.

Feldspar

Daddy Longlegs

Vein quartz with (possibly)
hornblende
Schist
Sandwich
Style!

small chunks
of quartz

chips of
muscovite mica

Tiny spiders

on the page

Very sparkly

Creek rock
with quartz
on top

quartz top

Unknown

ROCKS!

Meetinghouse Creek • lots of water critters still active •

distance • Chickadees • high trill of crickets • red-bellied

looks like a cookie!

ARROWWOOD
november 20

I found myself in a patch of piney woods today, on a path worn from use. I have always loved this path because the pine scent and the profusion of carpet moss reminds me so much of the woods I prowled as a child. Birds love these pines too. Today I heard chickadees, tufted titmice, goldfinches, and blue jays in the lower branches, and the soft *zzzzt* of kinglets way up high. A pine warbler landed nearby, and his chartreuse breast glowed against the dark trunk. These piney woods are also home to some of my favorite little evergreens: running cedar, grape fern, ebony spleenwort, and pipsissawa, also known as spotted wintergreen. A pine forest is the first place I go to look for a wide variety of mushrooms.

Today I settled down in a soft bed of pine needles to draw these striking arrowwood leaves. The branch reached out from behind a pine to get to the sun that fell where the path opened onto the field. Insects had nibbled on most of the leaves on the small tree, and every leaf was edged in black. The dappled afternoon sunlight hit the leaves just so and made the leaves glow like they were lit from within. Growing near the arrowwood was a Carolina jessamine, whose delicate vine was also growing out towards the sun of the nearby open field.

The warmth of the 60-degree day brought out the tangy scent of pines, which I must say blended nicely with the essence of drying grass that drifted in from the newly mown pipeline. A noisy flock of robins flew in and landed in a nearby pine. They stayed for about ten minutes and then flew on.

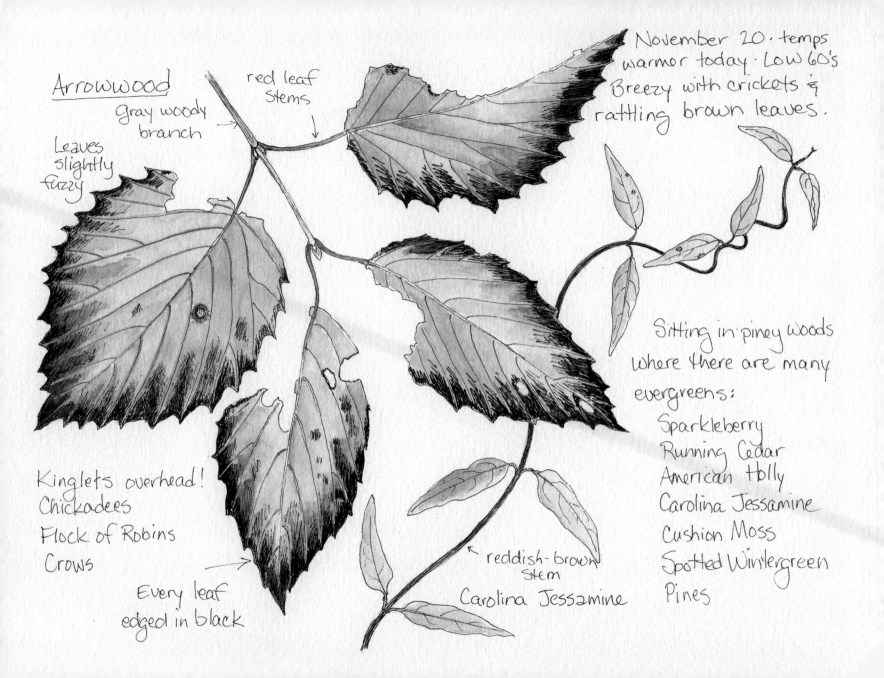

Arrowwood

red leaf stems

gray woody branch

Leaves slightly fuzzy

November 20. temps warmer today. Low 60's Breezy with crickets & rattling brown leaves.

Kinglets overhead!
Chickadees
Flock of Robins
Crows

Every leaf edged in black

reddish-brown stem
Carolina Jessamine

Sitting in piney woods where there are many evergreens:
Sparkleberry
Running Cedar
American holly
Carolina Jessamine
Cushion Moss
Spotted Wintergreen
Pines

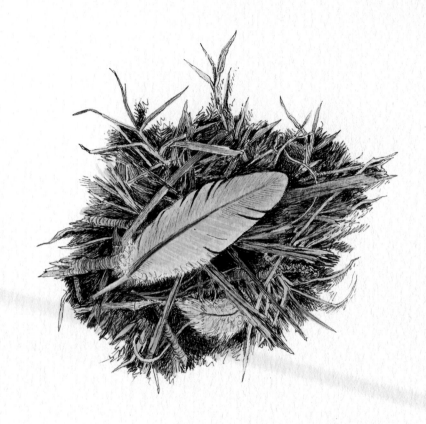

Winter

ASTER IN SEED
december 7

We headed out today under banks of heavy clouds and a wind from the north-east, which made it chilly, but soon the breeze died and the clouds drifted away and I felt warm with built-up body heat. On the way downhill a single purple aster bloom glowed bright against the dark woods.

Once past the creek I cut across the pipeline to sit on the south-facing side of the hill that rises steeply above Meetinghouse Creek. This is my favorite place to sit in the winter. The grass grows so short and thick that very few other plants can grow through it. The hill slants toward the southern sun, so on a cool day like this the microclimate can feel like Miami, plus it is close enough to Meetinghouse Creek for the dogs to play while I work.

I settled down to draw with my face to the sun. Chickadees, tufted titmice, gold finches, and kinglets chipped and cheeped in the woods, and crows called from distant trees. Carolina locusts leapt about on the hillside where they too were being warmed by the sun, and from where I sat I could see deer paths running every which way through the tall grass and briers. After a while I lay back for a few minutes and looked up into the sycamore tree in the woods behind me; it towered over me, its sunlit mottled bark stark white against a sky of cobalt blue.

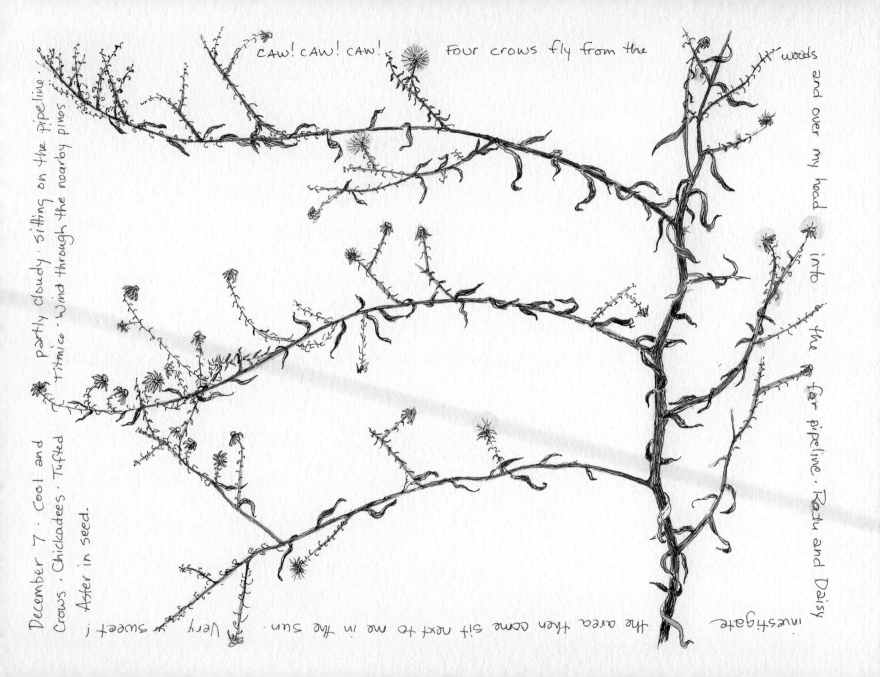

CAW! CAW! CAW! Four crows fly from the

words

and over my head into the far pipeline. Ruth and Daisy

December 7 · Cool and partly cloudy · sitting on the pipeline ·
Crows · Chickadees · Tufted titmice · Wind through the nearby pines ·
Aster in seed.

Very sweet! the area, then came sit next to me in the sun. investigate

LICHEN &
JELLY FUNGUS
december 8

*T*oday's early rain moved away around noon. When the dogs and I set out for a hike, water still ran off our high hill, trickling down a washed-out channel in the middle of Old Thompson Road, swirling and dancing over miniature waterfalls as it sought lower ground. Everywhere there were water droplets on branch tips sparkling in the sun like diamonds. The air was steamy.

Daisy and I headed for the piney woods. Soggy needles were so spongy we made no sound as we wound our way through the trees. We hopped across rain-swollen Meetinghouse Creek and headed uphill to the favorite old sourwood with a twisty trunk covered in fat chunks of furrowed bark. I sat to draw as the first gust of the day blew through the woods, but I found that I'd left my journal at home. Oh well.

By the time we got back to the house the wind had really picked up. I retrieved my journal, but the wind had become so strong it now roared. I heard a loud *CRACK* and turned in time to see a thick, multi-branched limb fall out of the top of a large oak. The limb was full of jelly fungus, which only grows on dead wood. During summer it is dry and scaly, but when the winter rains begin, the scales plump up into a slimy, jiggly mess too heavy for the dead branch to support, and *crack!* down they come. I broke off a piece and sat in the driveway to draw. On this branch I also found honeycomb fungus, and various lichens.

After curious sniffing, Daisy curled up near me but did not sleep. She kept one eye on the strange branch as I drew.

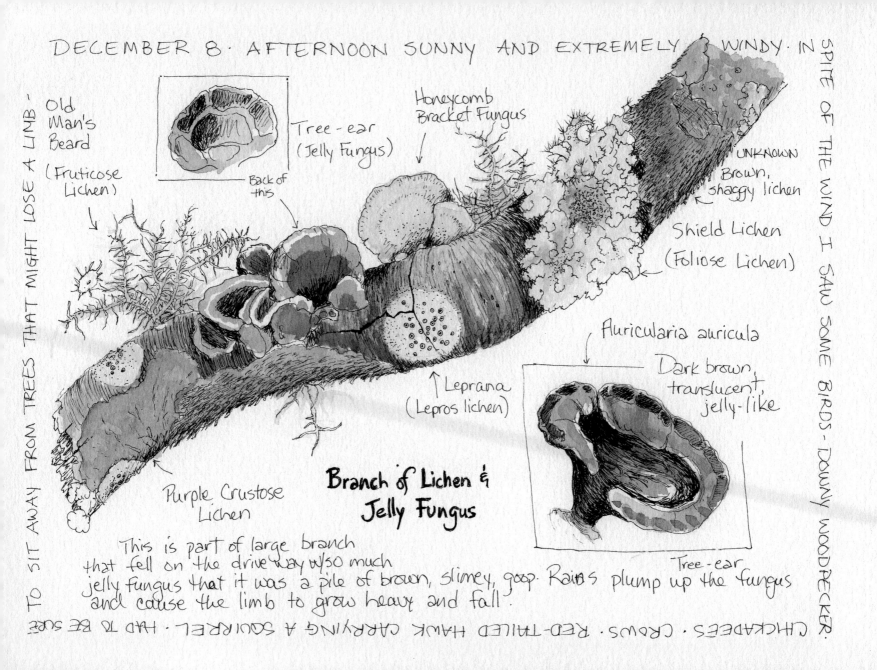

Old Man's Beard

(Fruticose Lichen)

Tree-ear
(Jelly Fungus)

Back of
this

Honeycomb
Bracket Fungus

UNKNOWN
Brown,
shaggy lichen

Shield Lichen
(Foliose Lichen)

↑ Leprana
(Lepros lichen)

Auricularia auricula

Dark brown,
translucent,
jelly-like

Purple Crustose
Lichen

Branch of Lichen & Jelly Fungus

Tree-ear

This is part of large branch
that fell on the driveway w/so much
jelly fungus that it was a pile of brown, slimey, goop. Rains plump up the fungus
and cause the limb to grow heavy and fall.

TO SIT AWAY FROM TREES THAT MIGHT LOSE A LIMB—

SPITE OF THE WIND I SAW SOME BIRDS – DOWNY WOODPECKER.

CHICKADEES · CROWS · RED-TAILED HAWK CARRYING A SQUIRREL · HAD TO BE SURE

Winged Sumac in Seed
december 16

*H*iking at the end of a busy day is a great way to work off stress. Today I started out with my backpack full of journal and supplies, but soon realized that what I really needed was a good, brisk walk. At the same time I noticed on the pipeline the graceful beauty of a patch of winged sumac in seed, their fuzzy stems and rusty red seeds arched like dancers taking a bow. I stopped short to admire them. How is it I haven't noticed these before today?

Leaving my backpack right there in the path, I headed off on my hike with the dogs. Down the steep hill we raced, through Meetinghouse Creek, up the far hill to the fence. Once I turned and headed back I noticed that our thin bit of sun, really just a fuzzy bright spot in a felt-gray sky, was about to be wiped out by a menacing dark cloud rising up from the western horizon. Sure enough, as I hiked home I watched the cloudbank slowly take over the sky. The temperature reflected the lack of sun.

By the time we hiked back up the steep hill to my backpack I'd worked up enough body heat to sit for a while and draw. I settled beside the pack and dug out the journal, accompanied by a flock of chickadees singing in the woods around me: *Chick-a-dee-dee-dee-dee-dee! Chick-a-dee-dee-dee-dee-dee!* The dogs wandered into the woods and then took off after a squirrel.

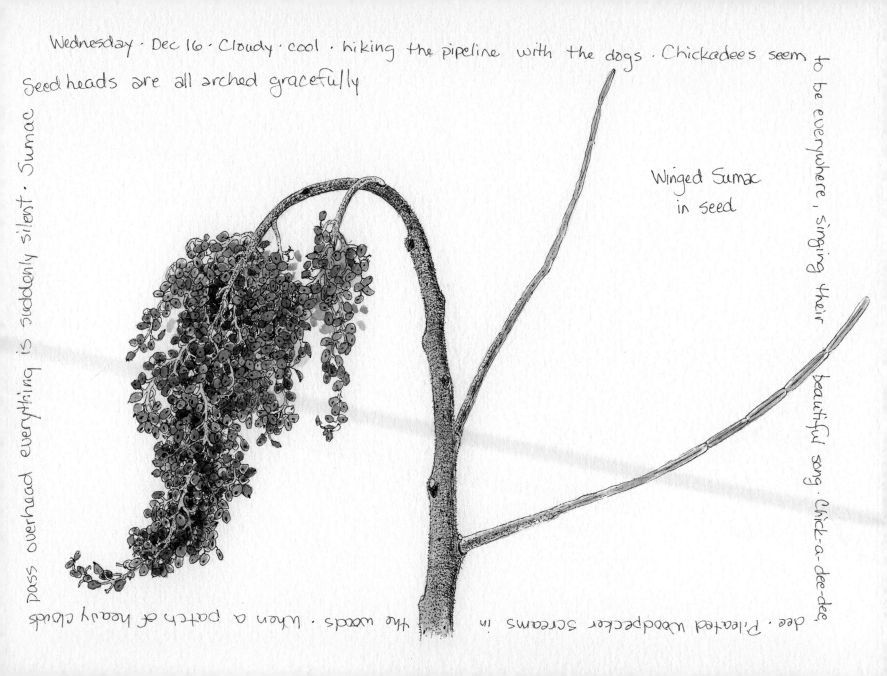

Wednesday · Dec 16 · Cloudy · cool · hiking the pipeline with the dogs. Chickadees seem

Seed heads are all arched gracefully

Winged Sumac
in seed

to be everywhere, singing their

beautiful song · Chick-a-dee-dee,

Sumac

pass overhead everything is suddenly silent · Sumac

dee. Pileated Woodpecker screams in the woods · When a patch of heavy clouds

WINTER SOLSTICE
december 21

The morning started off cold and windy, but by the time I hiked up to the top of the rocky ridge, back down to Meetinghouse Creek, and settled to draw on the sunny, northern edge of the pipeline facing the sun, it had become considerably warmer. Although at its lowest point of the year, the sun felt plenty strong as it flooded my fleece layers with its Solstice heat. Off came the scarf. Off came the hat. If I hadn't been intent on drawing hickory nuts I would have been tempted to curl up like a cat in the brown leaves.

While I drew I heard a crow in the distance and occasional chirrs and pecks from a hairy woodpecker. In the silence I heard tiny *click-clack-rattle* sounds in the leaf litter beside me. I turned to investigate, to see what critters had come to life in the sun. Five spiny soldier bugs, small brown beetles with yellow legs, were marching up and down and around on the leaves. *Scritch-scratch. Scritch-scratch.* As I watched the beetles, I noticed other movement. A tiny, two-inch-long green anole had crept up a large folded leaf to soak up some sun. He stretched. He blinked. I was surprised and delighted to see him acting rather like a cat—first he rubbed his face up and down many times on the edge of the leaf, like a cat will rub on a box edge or a chair, and then he used his back leg to scratch himself behind his head. I swear he did this, I saw it. He turned his face up to the sun. As he warmed he moved slowly on the big leaf, around and around in circles, until he finally slipped back into the leaf-litter underworld.

North wind · A train rumbles in the distance and blows its whistle · Deep blue sky

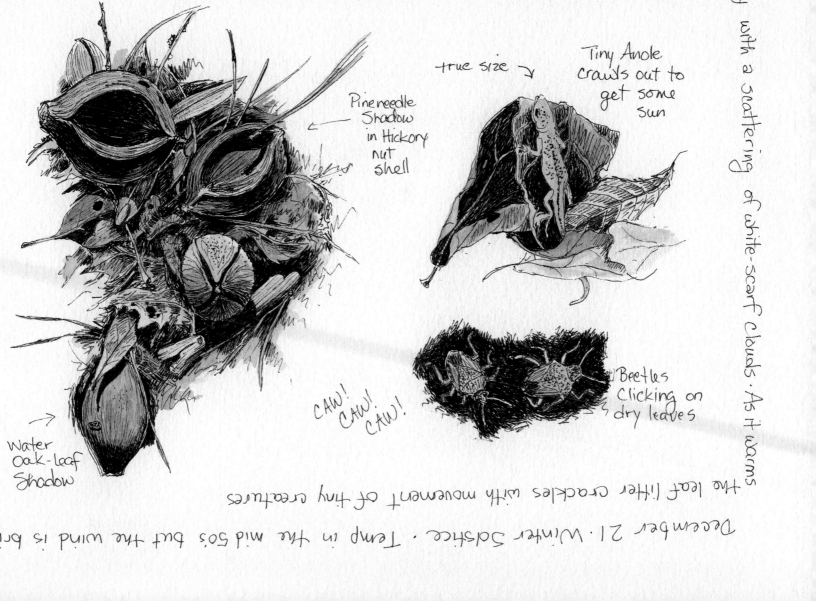

Pine needle
Shadow
in Hickory
nut shell

true size ↘

Tiny Anole
crawls out to
get some
sun

Water
Oak-leaf
Shadow

CAW!
CAW!
CAW!

Beetles
Clicking on
dry leaves

with a scattering of white-scarf clouds · As it warms

the leaf litter crackles with movement of tiny creatures

December 21 · Winter Solstice · Temp in the mid 50's but the wind is brisk ·

Found a spot in the sun with a hill behind to block the

GRASS SEEDHEADS
december 27

*T*his afternoon was bright and cold with a cloudless blue sky. The dogs and I hiked down to Meetinghouse Creek and headed into the piney woods beside the creek to a wide area that is covered in running cedar and patches of Christmas ferns. There are also lots of vines on the trees here: honeysuckle, crossvine, Carolina jessamine, cat brier, poison ivy, and wild grape, all of various diameter. I settled to draw the running cedar while the dogs ran and sniffed in the creek. Rays of sun found their way through the dense pine treetops and landed on the cedar, creating gorgeous spots of glowing yellow. All I could hear was wind in the trees and rustling brown leaves that still clung to three small red oaks nearby.

I drew for a while, but when the wind picked up even more, I became chilled and wanted to feel warm sun on my head. We hiked back out to the pipeline and resettled. Here I worked on drawing various seedheads left on the grass that grew about. During lulls in the wind I heard a mixed flock of chickadees, kinglets, and tufted titmice flitting about in the pines. A white breasted nuthatch came hopping down a nearby oak, calling his usual *ank ank! ank ank!*

We heard a strange *squeeeeeek!* Because it was the wrong season for a tree frog, I thought it might be a new bird. Daisy and I kept looking up into the trees trying to see what it was. Ha! It turned out to be two pines, one fallen trunk leaning on a live tree, rubbing as they blew in the wind.

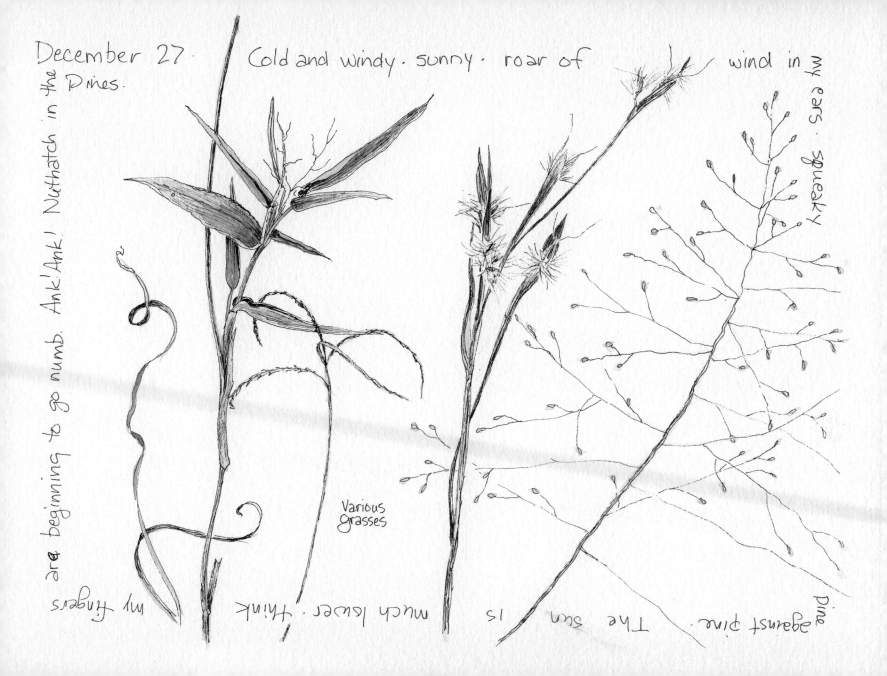

December 27. Cold and windy. sunny. roar of wind in my ears. squeaky

the Pines.

Various Grasses

(rotated text, left margin, reading upward): are beginning to go numb. Ank! Ank! Nuthatch in

my fingers much lower. think The sun is against Pine Pine

Sweet Shrub, Beautyberry, & Appalachian Oak-Leach

january 4

Today was cooooold! I headed out around 3 p.m. this afternoon wearing a scarf, hat, gloves, and silk long underwear, with tissues in my pocket. As we emerged from the woods a stiff breeze from the NNW swooped over the pines, fluffed Daisy's long, beautiful collie hair, and then blew straight down my neck. *Brrrr.* I zipped my coat up the last inch, wrapped the scarf one more time, and headed downhill.

Not far down the path I came to a big patch of red clay sprouting needle ice—tiny towers of ice crystals rising from the ground in graceful arcs. These were about three inches long, and each column was topped with a cap of clay that resembled little hats. I see needle ice out here on cold mornings following rainy days because the temperature of the subsoil is above freezing and the surface temperature is below freezing. As the surface water freezes it brings the moisture up from below. On a normal winter afternoon the ice has melted, but today's arctic blast has allowed these to stay all day.

Our hike was a quiet one. No muffled traffic, no dogs barking, no planes going over. Occasionally I would accidentally step on a patch of ice disguised by the clay caps and be surprised by the loud crunch it made. Back at the top of our hill, it felt good to collapse for a rest on our sunny bench. I started hearing birds: chickadees, titmice, red-bellied woodpeckers, and the constant *ank! ank!* of white breasted nuthatches. Soft *zeets!* coming from the pines were Kinglets. But it wasn't long before the cold started creeping back into my body. I hopped up and headed back to the house, collecting seedpods and berries along the way to draw inside.

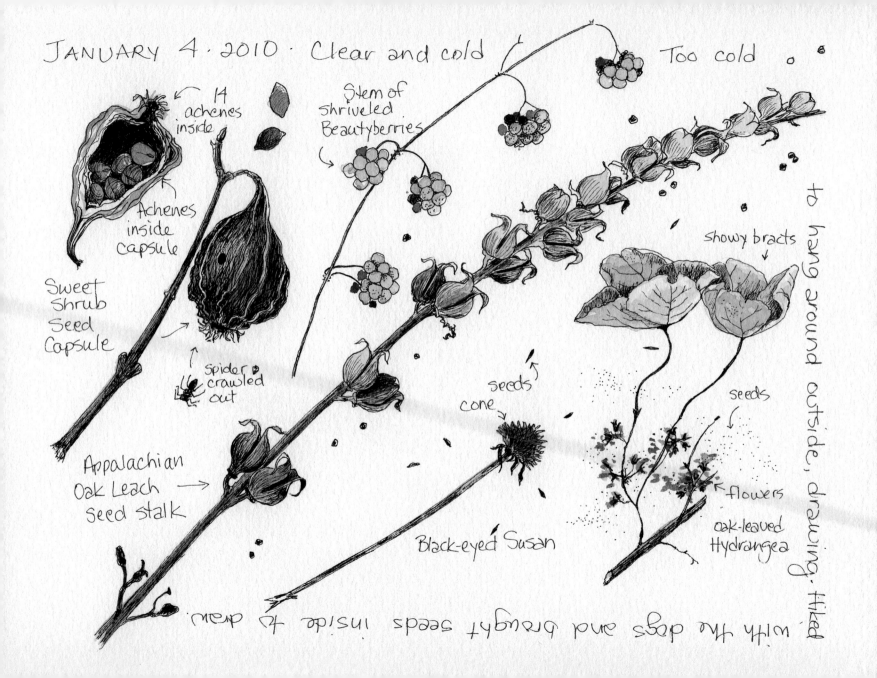

JANUARY 4 · 2010 · Clear and cold Too cold

14 achenes inside

Stem of shriveled Beautyberries

Achenes inside capsule

Sweet Shrub Seed Capsule

spider crawled out

showy bracts

seeds cone

Appalachian Oak Leach Seed stalk

seeds

flowers

Black-eyed Susan

oak-leaved Hydrangea

to hang around outside, drawing. Hiked with the dogs and brought seeds inside to draw.

Yucca Filamentosa
january 24

Years ago I discovered native yucca plants growing on the ridge above Lawson's Fork. I grew up in coastal Florida with Spanish bayonets, so I recognized the strappy evergreen leaves with pointy tips right away. It was the delicate white filaments curling along the leaf margins that made this plant distinctive. Today I decided to hike there and draw one.

To get there we hiked down Old Thompson Road, turning off to walk through an old home site slowly disappearing into the forest. Cedar and sweetgum trees grow from the square, leaf-filled hole that once was the basement, and through the mossy, stacked stone foundation. Wild grapes grow up the old chimney, one vine three inches in diameter. Out back, rotting from the bottom up, is the old barn, now only an angled tin roof sitting on the ground. Also around the homesite is an amazing bit of trash, remnants of the lives lived here: rusty cans with punched triangular holes, old bottles filled with moss and spleenworts, baby bottles, old light bulbs, Ball jars, broken milk glass mugs. Once, hiking through, I stubbed my toe on something invisible, turned back to see what it was, and found a curved metal edge rising an inch above the soil. A hard tug brought out an old-fashioned car horn, fifteen inches long, the horn opening five inches in diameter.

On the ridge I wandered around to find an appropriate sized plant to draw—not too big, not too small. Yuccas reproduce by both seed and offshoots, so there were all sizes from which to choose. This plant was just the right size, with plenty of curly filaments along the leaf margins. I settled beside it and drew until it became too cold to continue.

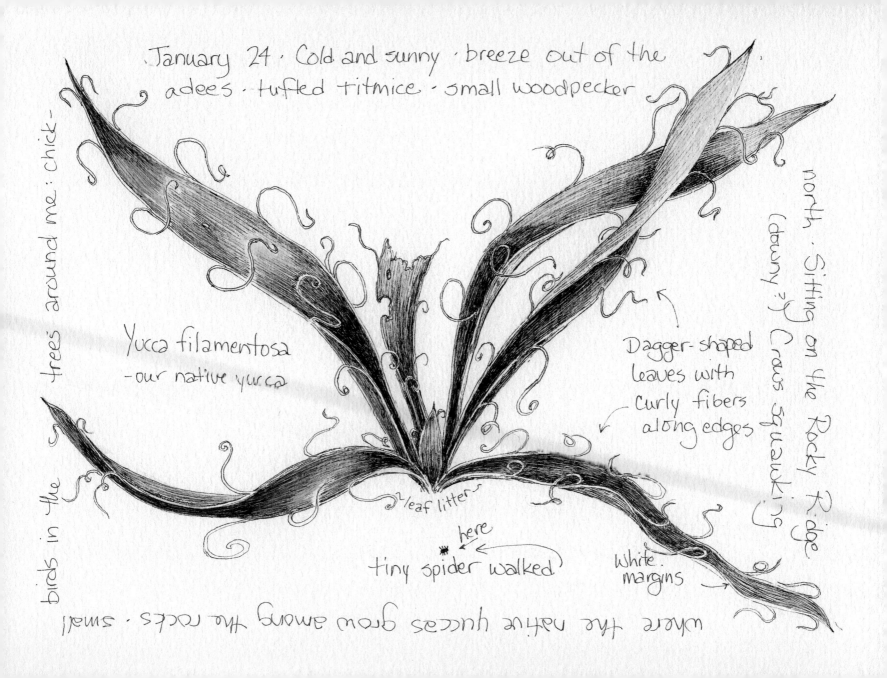

January 24 · Cold and sunny · breeze out of the
adees · tufted titmice · small woodpecker

Yucca filamentosa
-our native yucca

Dagger-shaped
leaves with
curly fibers
along edges

leaf litter

here

tiny spider walked

White
margins

north · Sitting on the Rocky Ridge
(downy?) Crows squawking

birds in the trees around me : chick-

where the native yuccas grow among the rocks · small

DOGWOOD
LEAF & DOWNY
WOODPECKER FEATHERS
january 26

Our unusual morning thunderstorm ended with dark scudding clouds overhead, parting occasionally to reveal tiny patches of blue. Finally the wind picked up, and the sun shone brightly.

The dogs, anxious to be off, dashed away down the front path. We wandered through piney woods until the wind rose high enough to break a branch and send it crashing down. Yikes! It's hard to know which trees have pine beetles and are apt to fall at any time, so we hurried on out of the pine woods. We passed by the big rocks at the sharp bend of Old Thompson Road. Near the stones, under years of leaf litter, rises a rusty metal bumper of a car. For all I know the whole car is down there, resting after missing the curve many moons ago. It's possible. Not far from here, in the woods at a sharp curve on Emma Cudd Road, lies the bent and rusted carcass of a '59 Chevy.

We stepped out onto the pipeline and headed in the direction of Lawson's Fork. Along the edge of the pipeline I noticed a dogwood leaf that was stuck on a small branch of the tree. The leaf shimmied in the wind, but, even in the gusts, never seemed in danger of being lifted off the branch that so neatly fit through the tiny leaf-hole. I wondered as I drew which came first. Was there a hole in the leaf when it fell and it just happened to fall in exactly the right way to get caught? Or did the leaf fall onto the branch, which punched the hole and held the leaf as it dried? I know, I know … not one of life's big mysteries, but I wonder just the same.

JANUARY 26 Rain has moved out – strong winds have blown

Woodpecker

feathers!

A low plane buzzes us.

Hairy or
Downy

today !! Caw!Caw!

Leaf hung on a
Dogwood tree –
wiggling in the
wind –

in and pushed away the clouds – we wandered around.

Daisy, Atticus
and Cookie all
following me around –
stepping and climb-
ing on everything I
stop to admire –

Lots of Crows out

Cordyceps Capitata on South-Facing Slope
january 28

The steep slope Daisy and I explored today faces south and drops down to Meetinghouse Creek at its confluence with Lawson's Fork. We crunched through brown leaf-litter that covers the hillside, and although Daisy bounded up the hill without pause, I had to take careful steps so I wouldn't slide, and occasionally grab onto small trees to pull myself up. Boulders large and small are scattered about, making the ridge top an ideal resting spot with a great winter view. To the east, through naked trees, you can see across Meetinghouse Creek to where the ridge continues on the other side, and, to the north, through tall mountain laurels you can see Lawson's Fork sparkling below.

While resting I noticed a wildlife track leading uphill at an angle, so I followed it. We topped the ridge and I was about to follow Daisy into the laurel thicket when she stopped short and started barking like crazy at something I couldn't see. No telling what it was. But I trusted that there was *something* there—fox, coyote, and bear came to mind—so I did not go that direction. Instead, I went down the hill a bit and by doing that discovered two tiny black mushrooms growing along the ridge. While investigating, I brushed the leaves away to expose strange yellow stalks, the larger only two inches long. I later read that they are *Cordyceps capitata*, common name, headlike cordyceps. They arise from an underground, truffle-like fungus. Interesting note: these are hallucinogenic mushrooms, used by shamans in Mexico for divining the future.

Obviously I am *not* a shaman, because after I finished the sketch, instead of picking the mushrooms I replaced the protective leaf litter around them and headed home.

Cordyceps capitata
growing on a
steep bank

January 28 · Hiking on the
south-facing slope above Meetinghouse Creek

Don't know what
this plant is -
leaf petiole is
4" long

Growing on steep,
south-facing slope.

Stink
bug

Chickadees · temps in the 50's · partly cloudy.

Blue Jays · Red-bellied woodpecker.

BEECHDROPS, HEARTLEAF, & TUFTED TITMICE
january 29

*I*f you sit long enough and are very quiet, you get to see special things in nature. Today, for example, I finally settled against an oak tree to sketch the heartleaf I'd discovered along Meetinghouse Creek. As I sketched, *scritch scratch,* I heard birds about. They got closer and closer, and louder, until I finally realized that a mixed flock of birds had come to Meetinghouse Creek to bathe. I've read that this is a common practice for birds, but every time I see it I am amazed. Today, groups of robins, tufted titmice, yellow-rumped warblers, chickadees, as well as goldfinches and a lone downy woodpecker perched above and around me, flying down to the shallow pool behind a fallen log in the slow-moving creek, to splash and wash, then fly back to a branch to dry. They're very vocal during this activity, possibly calling to each other, *My turn! My turn!*

Across the creek from where I sat grew a huge beech, so after the birds left I went in search of beechdrops, strange little plants with no leaves or chlorophyll, and parasitic to beech tree roots. They are fall bloomers, so the stems I found today are stalks left from last fall. The other plants I drew were growing nearby in the damp, cool soil along the creek, in a place our family calls Coon Hollow because of the high, shady bluff on the southwest side of the creek that protects the area from sun and wind. The sandy banks and beaches along its course are always full of raccoon tracks, hand-like prints left from their nocturnal outings.

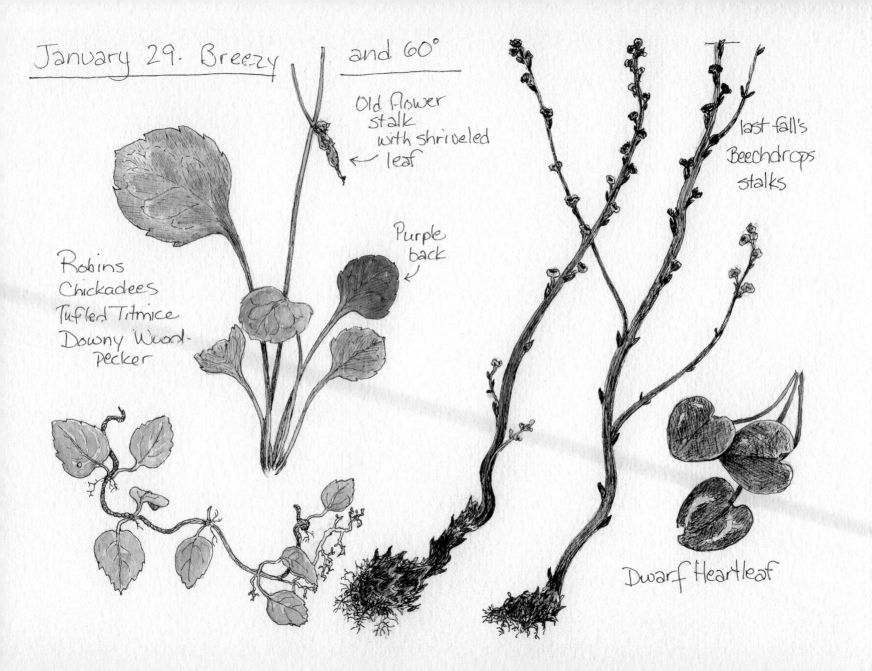

January 29. Breezy and 60°

Old flower stalk with shriveled leaf

Robins
Chickadees
Tufted Titmice
Downy Wood-
Pecker

Purple back

last fall's Beechdrops stalks

Dwarf Heartleaf

Oak Leaves on the Rocky Ridge
february 3

I found these leaves on the rocky ridge above Lawson's Fork while hiking with my husband and the dogs last weekend, which was warm—almost 70 degrees—and sunny. The lacy pattern on the post oak leaf was quite striking, noticeable even mixed in with all the other billion fallen leaves scattered across the forest floor.

The other leaf was obvious because of the polyphemus moth cocoon. I've never seen one of these cocoons attached to a leaf like this; usually they are dangling from a branch or twig at the edge of a tree's canopy. The moth that emerged from this cocoon is the same rusty brown of winter leaves and has beautiful eyespots on all four wings. I know, because we've had one visit the side porch light at Middlewood, and then stay for a day on the cedar shingled wall. The polyphemus, like the luna moth, has no mouth, so they never eat. They just mate, lay eggs, and die, and look beautiful all the while.

The weather has turned cold again this week. As I post, I'm wearing my silk long underwear for warmth, and sleet is clicking against the windows. And even though last weekend's warm days were nice, I love winter! I love the naked trees, and seeing the lay of the land through the hardwood forests. Plus, I am still hoping for one beautiful snowstorm before spring … just one.

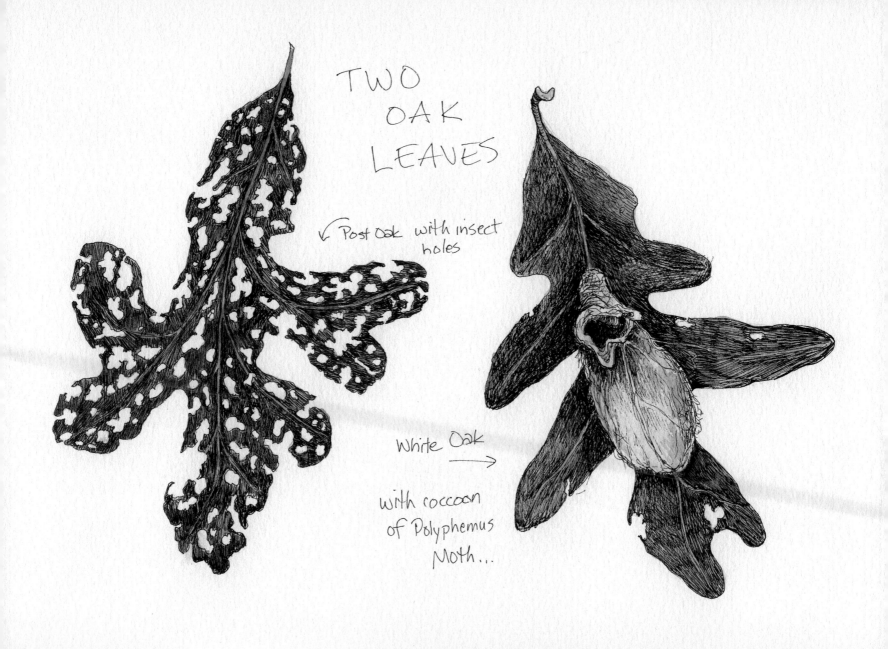

TWO
OAK
LEAVES

↙ Post Oak with insect
holes

White Oak ⟶

with coccoon
of Polyphemus
Moth...

CRANEFLY ORCHID, EUONYMUS, & SPOTTED WINTERGREEN

february 8

This afternoon was chilly, but the sun shone. No mist, fog, or threatening rain; no slick red mud, no snow or ice. I had no plans or articles due, no book to read for class; a pot roast bubbled in the crock-pot. Everything pointed to *GO*, so I high-tailed it into the woods.

My goal was to find a nice, quiet spot in the woods where there was something colorful to paint, even though I know in early February there are very few colorful things out in nature. By chance, I found one. Some animal—probably a deer—had stepped on a leaf of a cranefly orchid and broken the stem. As I snuck through the tangled woods on the steep bluff over Meetinghouse Creek, I saw the leaf glowing purple amid the brown oak, beech, and maple leaves from fall. The backside of the single cranefly orchid leaf is always this stunning color. The front is beautiful in its way, always strongly ridged and rippled, but it comes in the expected color: green.

I sat to draw and found other subtle wildflowers that grow in the same cool, north slope environment: spotted wintergreen, this one with a dried seedpod; euonymus with typical deer-chewed stems; and partridgeberry vines (no berries) crawling over a tuft of moss. Just as I started drawing the sun went behind clouds. It was quiet. The only bird I heard was a talkative crow perched in a tree behind me. He made many of his weird, garbled conversational calls, as well as his usual, loud *CAW! CAW!* The creek below rippled along its course.

February 8 · Chilly · Sunny when I headed out, cloudy now · Sitting other · the creek gurgles below ·

new
← buds

Euonymus nibbled to a nub by deer →

Partridgeberry on moss

Spotted Wintergreen in seed

Cranefly Orchid leaf broken off by wildlife

back

front

a sourwood or two · Crows call out to each

Mantis Case, Blue Curls, Thistle, & Dodder

february 17

This afternoon was cold and windy, with white puffy clouds scooting across a cobalt sky. Patches of snow left from last week's event along our road and Meetinghouse Creek prove how cold it's been.

Cold or not, I grabbed my backpack and headed out with the dogs. We hiked towards the pipeline, the dogs running and turning to make sure I followed. *Oh boy! Oh boy!* They were wired! We headed east, with the sun on my back. My goal was to build up body heat first, and then sit to draw with the sun in my face for warmth.

The plan worked so well I got hot, and soon I'd shed my scarf and coat and was luxuriating in the warmth of the afternoon sun. *This is it,* I thought. *It feels like April!*

I settled on the path close to Meetinghouse Creek, next to the thick tangle of cat brier, sumac, goldenrod, and other plants that grow well in sun and damp soil. In the tangle I noticed a small bull thistle seedhead and went in to retrieve it. I snapped it and took it back to my seat. I also picked the top of a winged sumac with black dodder seedhead vines spiraling up the stem, a praying mantis egg case, and the dainty bracts of last fall's blue curls.

The dogs sat close by me while I drew until, with no warning, one of those nice, fluffy white clouds had the nerve to scoot itself right over the sun. The temperature plunged, and the wind picked up. *Brrr.* Goodbye April.

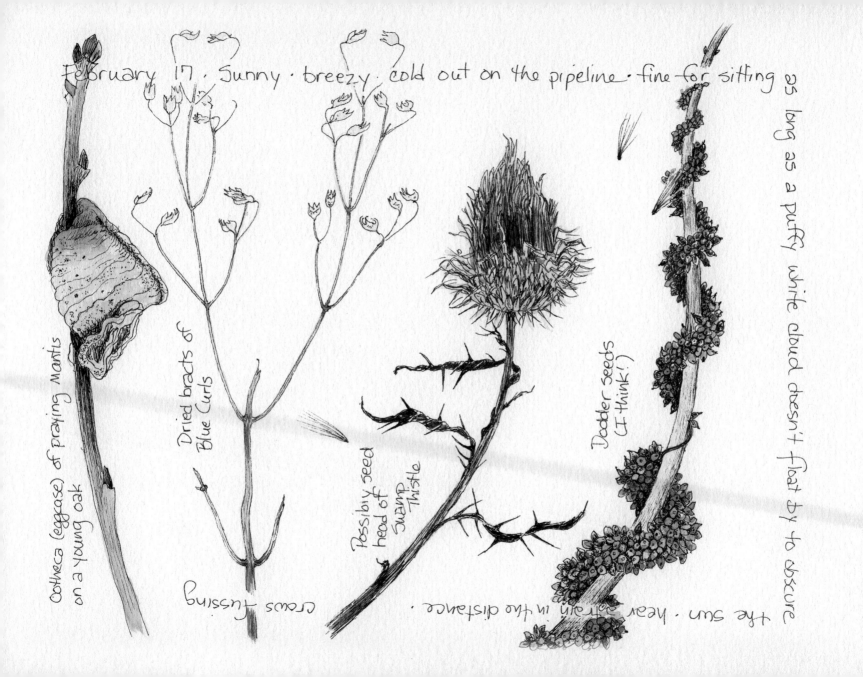

February 17 · Sunny · breezy · cold out on the pipeline · fine for sitting

as long as a puffy white cloud doesn't float by to obscure

the sun · hear a train in the distance · crows fussing

Ootheca (eggcase) of praying Mantis on a young oak

Dried bracts of Blue Curls

Possibly seed head of Swamp Thistle

Dodder seeds (I think!)

Vines Along the Creek
february 20

The world was silent today. Overcast and still. On the way downhill toward Meetinghouse Creek, I stopped to listen. Surely something was moving out there. Once, I heard tiny clicks in the leaves that sounded like raindrops on leaf litter but figured it must be insects moving beneath the leaves. I saw three deer way up the next hill. Daisy saw them too and took off on a futile chase. Even her mad dash seemed to make no noise.

I reached the creek and turned left along the bank, ducking into the tangled vines and pines that flourish along the edge of the pipeline. Under the pines, the forest floor is covered in an emerald green carpet of running cedar. From a distance the carpet looks smooth and solid, but as you get closer branches and scaly leaves take shape. By this time Daisy had lost her deer and returned to me. She nosed ahead and walked down a worn deer path to the creek. I followed.

Vines grow thickly all along the creek. In one place all these vines were climbing two trees before me: poison ivy, partridgeberry, cross vine, common greenbrier, wild grape, honeysuckle, and Carolina jessamine. I settled on the edge of a small, sandy ridge along the creek and pulled out my journal. It was still quiet except for a woodpecker *knock-knock-knock*ing on a tree a short distance away. Five minutes later other birds seemed to come to life: goldfinch, titmice, crows, cardinals, kinglets, chickadees, pine warblers, and a pair of red-bellied woodpeckers. Daisy came and sat so close she was leaning on me. Her warmth on my back was very comfy and snuggly—one of the best reasons to be a dog person.

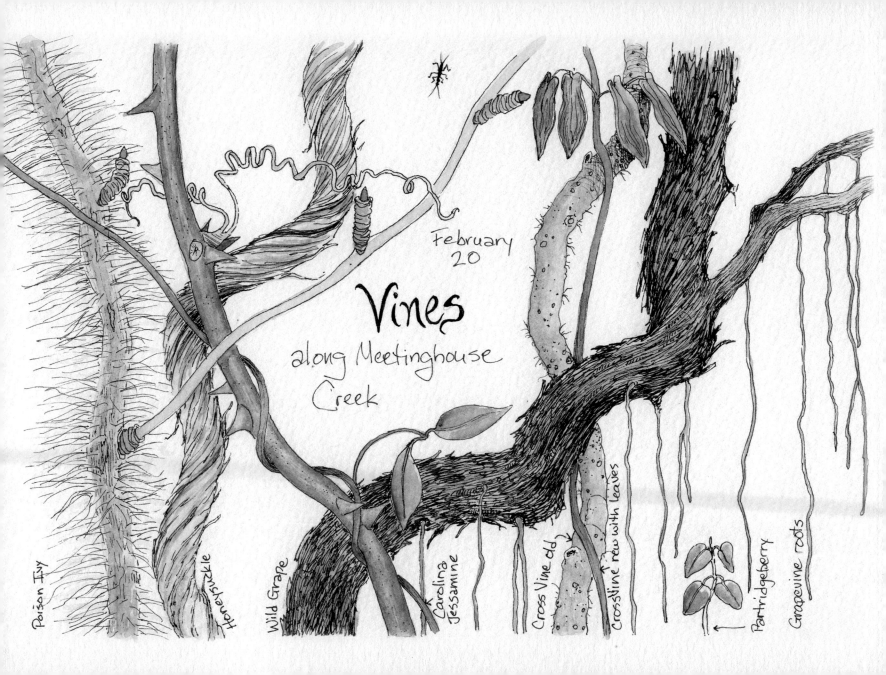

February 20

Vines

along Meetinghouse Creek

Poison Ivy

Honeysuckle

Wild Grape

Carolina Jessamine

Cross Vine old

Crossvine new with leaves

Partridgeberry

Grapevine roots

Sun Bleached
Deer Bones
february 21

After a stretch of cold, wet weather, today was just what I've been longing for: temps in the mid-60s, sunny, and not one puffy cloud to block the sun. Spring peepers sang so loud in the Glendale wetlands as I drove past this morning that I could hear them with the car windows shut. I opened them and felt the mild air rush in.

We headed out at 4 p.m. and hiked straight down to Meetinghouse Creek. The warm air felt glorious in my face, and the sun's heat on my back like a hug from a good friend. Daisy stuck with me. When we got to the creek she came to stand beside me as I squatted beside the rippling water to inspect the rocks. She's a curious dog and often wants to see and sniff whatever I'm looking at. I held up some rocks to her, and after sniffing she seemed satisfied. I pocketed a nice chunk of yellowish feldspar and we continued on. In the woods beside the creek I found the white weathered shell of a box turtle (missing the thin outer tortoiseshell layer), and an old bottle turned greenhouse, stuffed with bright green moss and partridgeberry vine.

While attempting to cross the brier-tangled middle pipeline I noticed a pile of sun-bleached bones on the opposite side of Meetinghouse Creek. I crossed over to investigate. They turned out to be the skeletal remains of a young white-tailed deer, probably a year or so old. I picked up various bones and found a place in the sun to draw. Daisy settled next to me and fell asleep. The only sounds I heard were chickadees and a few raucous crows, squawking about something important in Crow World.

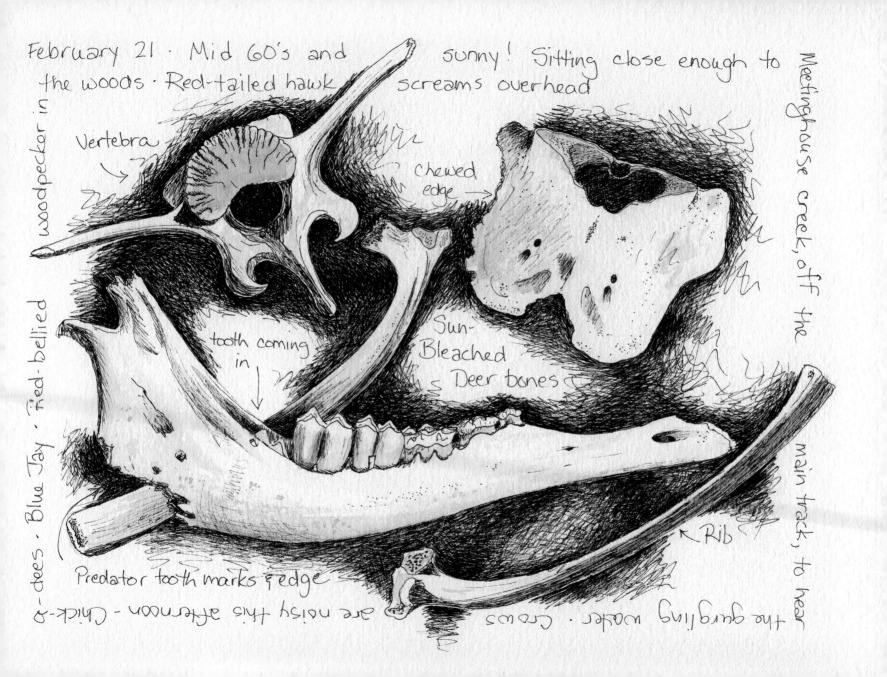

February 21 · Mid 60's and sunny! Sitting close enough to
the woods · Red-tailed hawk screams overhead

Vertebra

chewed
edge

tooth coming
in

Sun-
Bleached
Deer bones

Predator tooth marks & edge

← Rib

Meetinghouse creek, off the main track, to hear

woodpecker in

Red-bellied

Blue Jay ·

chees ·

a-

Chick-a-

are noisy this afternoon · Crows

the gurgling water ·

HUB CITY PRESS

Hub City Press is an independent press in Spartanburg, South Carolina, that publishes well-crafted, high-quality works by new and established authors, with an emphasis on the Southern experience. We are committed to high-caliber novels, short stories, poetry, plays, memoir, and works emphasizing regional culture and history. We are particularly interested in books with a strong sense of place.

Hub City Press is an imprint of the non-profit Hub City Writers Project, founded in 1995 to foster a sense of community through the literary arts. Our metaphor of organization purposely looks backward to the nineteenth century when Spartanburg was known as the "hub city," a place where railroads converged and departed.

Recent Hub City Press titles

Rockin' a Hard Place – John Jeter

The Patron Saint of Dreams – Philip Gerard

The Iguana Tree – Michel Stone

The Underground Guide to Spartanburg – Joe Mullinax, editor

Artists Among Us – Edward Emory and Stephen Stinson, editors

Home is Where: An Anthology of African American Poetry of the Carolinas – Kwame Dawes, editor

Waking – Ron Rash

Banjos, Barbecue & Boiled Peanuts – Kirk H. Neely